David Dave

The Power of Paper
in Graphic Design

ROCKPORT

The Power of Paper
in Graphic Design

GLOUCESTER MASSACHUSETTS

ROCKPORT PUBLISHERS

Catharine Fishel

First published in the United States of America by
Rockport Publishers, Inc.
33 Commercial Street
Gloucester, Massachusetts 01930-5089
Telephone: (978) 282-9590
Fax: (978) 283-2742
www.rockpub.com

ISBN 1-56496-933-9

10 9 8 7 6 5 4 3 2 1

Design: Hatmaker
Production and Layout: Leeann Leftwich Zajas
Cover Design: Mono
Project Manager/Copyeditor: Stacey Ann Follin
Proofreader: Karen Diamond

Printed in China

Hi hi, kechuwa.

Graphic designers are, to a fault, good and generous people. Many, many thanks to each of the talented designers and artists who responded so positively to this project and allowed their work to be shown here.

Also, thank you to Yupo Paper for its generous donation of the plasticized paper (62 lb. Translucent TPGA 90 and 58 lb Cover FPG 250) for the cover and divider pages of this book.

Contents

Introduction

There appears to be three movements afoot today in paper manufacturing and specification, one functional and two purely aesthetic. Each bodes well for graphic designers.

The first effort is toward producing papers that designers and nondesigners alike can use in any application: for offset printing, in laser and inkjet machines, in digital presses large and small. These "wonder papers" are a real boon to designers, allowing them to cross printing platforms within the same job when necessary so, for example, they can use offset printing for large quantities of company-wide business cards and later use inkjet printing to apply person-specific information.

Going back 10 years, these papers tended to be pretty vanilla in appearance and heft. Today, however, choices abound. Everything from vellums to card stocks are available in almost every color and texture imaginable.

The second movement in paper production is unabashedly all about looks. Paper manufacturers, perhaps in response to dire—and as it turns out, empty—threats of the paperless society have developed wide lines of unusual and beautiful papers, many well within the budgets of most clients. There's Bier Paper from Gmund, which is as thick and satisfying as an English stout. Plasticized papers, like those offered by Yupo, which cover this book and also serve as divider paper, are another highly printable and durable option. Finally, there are stocks that are just plain gorgeous to look at and run through one's fingers, like French Paper's Frostone, any of Curious Paper's sheets, and a greatly expanded selection of handmade papers from all over the world.

The third movement is being driven by designers themselves. There is a marked return to basics: simple printing on simple papers. Citizens of a tumultuous world, many artists are searching for ways to be more forthright with their messages, to say what they want to say without flash. Witness the number of minimalist designs in this book: Each uses paper in its basest form, and each succeeds in quietly provoking emotion.

Is there a moral? Perhaps it's that the more things change, the more they stay the same. Wider and deeper selections of papers are available, but designers tend to come back to what they already know works best. Sure, you can get paper made from hops or seaweed, but papers with high cotton content continue to sell well.

As in *Paper Graphics*, the work shown in this book can be divided into three
main types:

- conceptual designs that trade off on common conventions, such as a cocktail
 napkin covered with the brainstorming scrawl of a designer searching for a new
 name for his firm;
- aesthetic pieces that provoke the viewer through their visual or tactile nature; and
- performance pieces in which the paper that is specified must behave well and
 even excel in diecutting, embossing, or other specialty printing processes.

Paper is no longer a simple carrier for information. It can and should be part of the
message itself. Its energy comes from the designer, who performs the sleight of hand
that transforms a thin, lifeless sheet of formed fiber into a powerful tool.

Paper may be disposable, but it's also indispensable. My 6-year-old likes to modify the
old, familiar game Rock Paper Scissors by substituting new elements. Rock Paper
Taco and Brontosaurus Paper Scissors are two current favorites. But no matter how
we try to change the composition of the challenge, "paper" can't be removed without
irrevocably changing the nature of the game. Nothing else does what it does.

It's the same in design. Paper is a crucial part of the game.

—Catharine Fishel

Functional Paper

CHAPTER 1

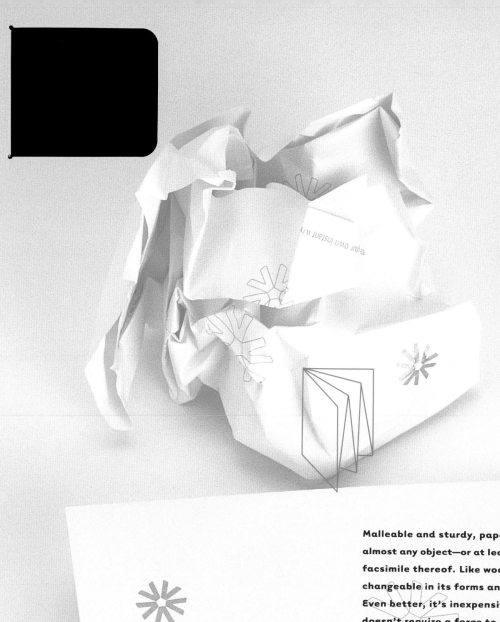

Malleable and sturdy, paper can be made into almost any object—or at least into a pretty convincing facsimile thereof. Like wood or metal, it's endlessly changeable in its forms and in what it can form. Even better, it's inexpensive and lightweight. It doesn't require a forge to be shaped: The human hand can supply enough force to change its form.

Can paper be formed into furniture? Can it be made into a toy? Can it be turned into a gift that sparks the imagination? Yes, yes, and yes. What designers want paper to do, it'll do, with the help of clever printers and fabricators.

Radio Smithsonian

Design firm

KINETIK Communication Graphics

Designers

Jeff Fabian, Sam Shelton, Beverley Hunter, Mimi Masse, Scott Rier

Printer

Globe Screen Printing

Client

Radio Smithsonian

Paper

Coated one-side chipboard

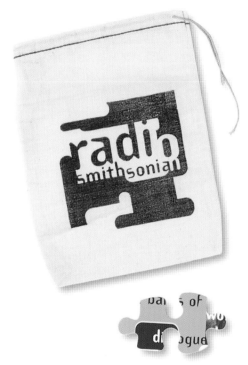

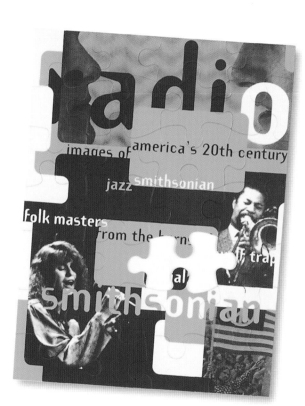

Radio Smithsonian is a producer of radio programming that is picked up by stations worldwide. For one of the two major radio conferences that are held each year, the client wanted a handout for attendees that said, "Radio Smithsonian can help you with your programming puzzles." The obvious visual direction for designers at KINETIK Communication Graphics was to produce an actual puzzle. It's silk-screened onto chipboard—cheap and sturdy—then it's punch cut by a puzzle manufacturer. The design is given out flat—that is, all on one piece—together with a small drawstring bag to hold the pieces once the puzzle is disassembled.

no.parking

Design firm
no.parking

Designers
Caterina Romio, Sabine Lercher

Client
Self-promotion

Paper
(2000 card) Endless uncoated paper;
(2002 card) 250 g/mq Magnomat Satin

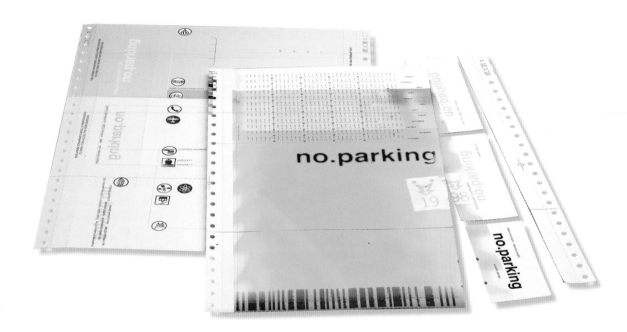

The designers at no.parking in Vicenza, Italy, like to reuse and recycle items. These two self-promotional and multifunctional mailers are examples of how they can stretch a single design's use. Both of these New Year's cards can be torn apart after the recipient takes in the greeting: Perforations permit the piece to be separated into business cards and a calendar, yet still keep the card itself operational as a greeting. Getting names and phone numbers out to many people was important to the company since it was new at the time these were sent out.

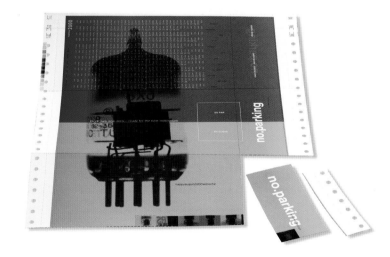

SK Designworks Inc.

Design firm
SK Designworks Inc.

Design and art direction
Soonduk Krebs

Client
Self-promotion

Paper
130 lb. Mohawk Superfine cover

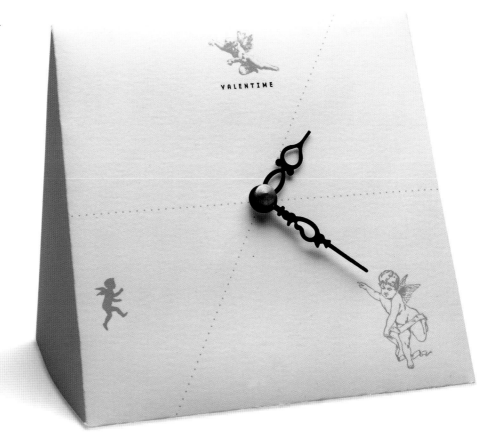

SK Designworks produced this Valentine's Day promotion
as a timely self-promotion for friends and clients, subtly
changing the title on it to "Valen*time's* Day." The 4 $^1/_2$ x 4
$^1/_2$ x 4-inch (11 cm x 11 cm) clock really does have works
inside, and these needed to be structurally supported.
Designer Soonduk Krebs selected a sturdy cover stock for
this purpose; its bright white surface helps to reinforce the
simplicity and shape of the clock.

Meyer & Liechty

Design firm
Meyer & Liechty

Creative directors
Christopher Liechty, Hailey Meyer

Designers
Thomas Melanson, Hailey Meyer

Illustrator
Hailey Meyer

Silkscreen printer
Rory Robinson

Client
Self-promotion

Paper
Library board

The design firm Meyer & Liechty created this charming Harlequin pull toy as a self-promotion, sent to about 150 clients and personal contacts around the world. The designers' intent was to create an object that people would enjoy—thereby associating the firm with fun and creativity—and that they could not bring themselves to throw away.

The approach worked: One of Meyer & Liechty's clients recently completed a worldwide tour of marketing offices and discovered that many people still had the toy hanging in their offices.

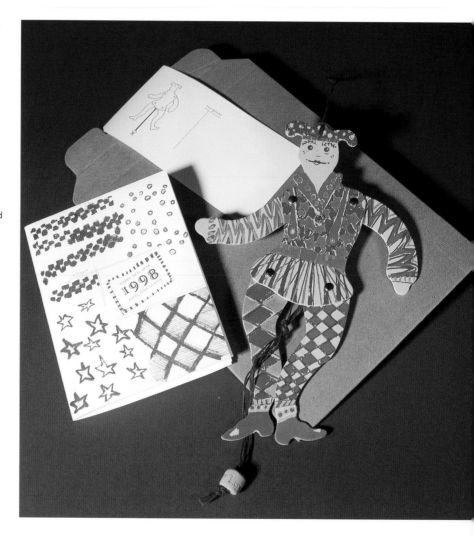

SooHoo Designers

Design firm
SooHoo Designers

Creative and art directors
Patrick SooHoo, Kathy Hirata

Designer
Cindy Hahn

Copywriter
Jay Oswald

Client
Self-promotion

Paper
80 lb. Potlatch McCoy Silk cover

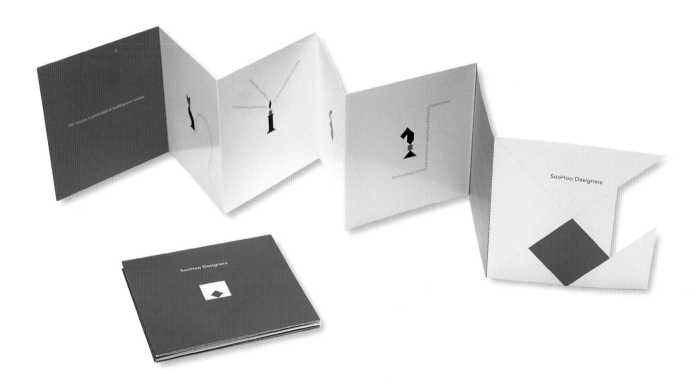

The SooHoo Designers creative team wanted to send clients a self-promotion
that explained the concept and background of its tangram identity. However,
when the designers realized that making a custom tangram out of materials like
wood and metal would be cost-prohibitive, perforated paper emerged as an
ideal alternative. The designers hope that recipients will embrace their creative
philosophy and approach to problem solving, derived from the ancient Chinese
puzzle. Once the printed piece is torn along its perforations into its intended
pieces, it should challenge the viewer into constructing images that use all
seven elements at one time.

Aspen Traders

Design firm
Gardner Design

Designers
Bill Gardner (three-dimensional folds); Travis Brown
(five-sided box with moth closure and five-sided box
with magenta and orange stripes)

Client
Aspen Traders

Paper
Various

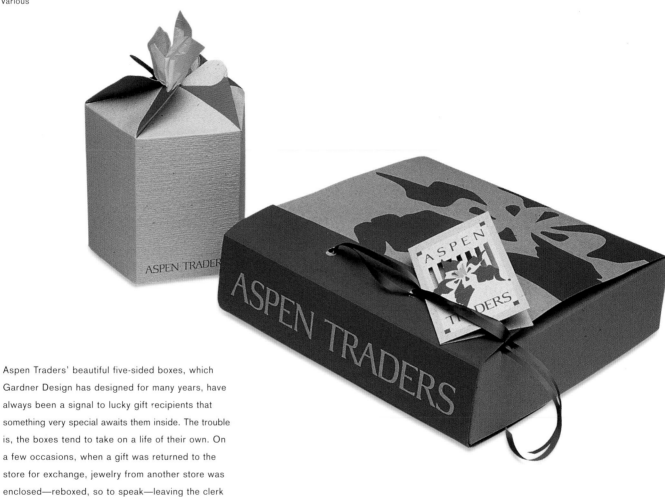

Aspen Traders' beautiful five-sided boxes, which
Gardner Design has designed for many years, have
always been a signal to lucky gift recipients that
something very special awaits them inside. The trouble
is, the boxes tend to take on a life of their own. On
a few occasions, when a gift was returned to the
store for exchange, jewelry from another store was
enclosed—reboxed, so to speak—leaving the clerk
to break the news that the giver had simply recycled
a desirable Aspen Traders' box. To overcome this
challenge, last year Gardner Design created a new
signature box—just as beautiful, but when its seal is
broken, it can't be reclosed.

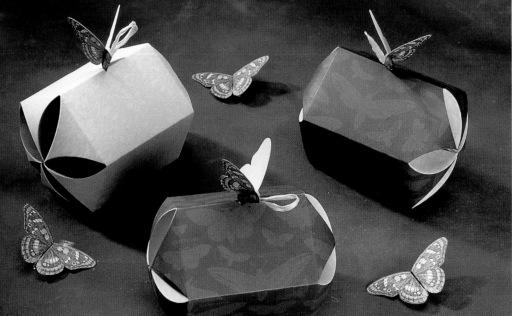

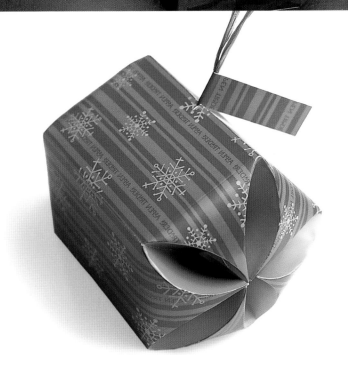

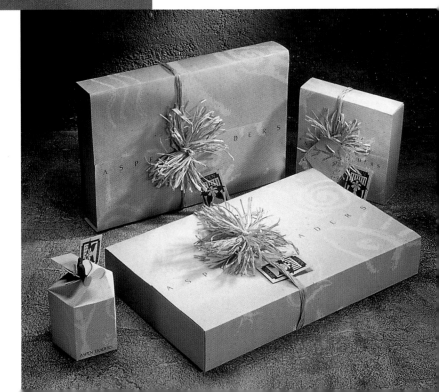

Eric Janssen Design

Design firm
Eric Janssen

Client
Eric Janssen Design

Paper
Formed postconsumer waste pulp (stool) and cardboard tubes (rack)

Photography
Erma Estwick (rack)

Designer Eric Janssen likes to experiment with different media, usually common items like paper, in new and unexpected applications. The Pulp Stool and Weekly Wine Rack are two successful experiments. Fast-food drink trays inspired the stool (bottom right). "People just don't think about sitting on paper," Janssen explains. He even worked with one manufacturer to produce an easy chair, but this item's sheer size caused it to collapse on itself before its fibers could set properly. But the stool, with its cylindrical shape, supports itself as it's formed, baked, and dried. At only five pounds, it's also stable enough to support a person's weight.

The wine rack is made from cardboard shipping tubes, which Janssen has manufactured to fit his specifications. However, even with careful toler-ances, the environment can affect his product: Humid conditions cause the tubes to swell and not fit together, and cold, dry weather makes them shrink and not fit snugly. "I like the contrast between production and packaging techniques. It's a relatively inexpensive process when you compare it to what metal or plastic molding would cost for a similar item," he says.

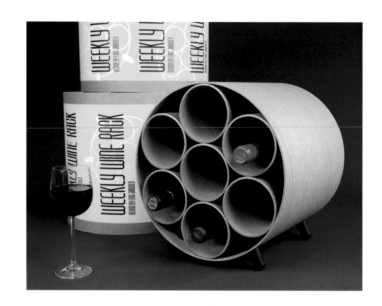

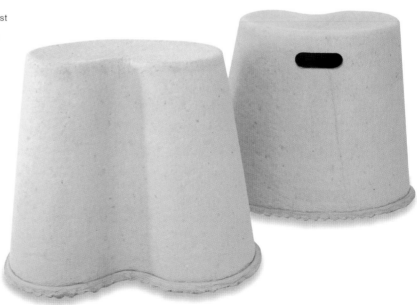

The Corporate Travel and Meetings Forum

Design firm
Bull Rodger

Design
Nial Harrington

Copy
Paul Rodger

Production
Hythe Offset

Paper
PhoeniXmotion 115 gsm

Here logo is made flesh in the designs that Bull
Rodger created for The Corporate Travel and
Meetings Forum. The London-based design firm's
identity for a travel conference, which was to be
held aboard a ship, was a paper boat made from
a page of a travel brochure. Making the invitation
to the launch—as well as the client's business
cards—into actual boats seemed liked the natural
thing to do, reports firm principal Paul Rodger.

"Isn't paper a wonderful material?" he adds.

Katy Parkinson
Project & Conference Manager
t +44 (0)20 8487 2211
f +44 (0)20 8487 2311
kparkinson@richmondevents.com

On Monday 12 June, from 18:45hrs for lite bites and drinks,
in the Library at The London Marriott, County Hall,
followed by a spin on the London Eye at 21:00hrs

Happy Monday

Design firm

Happy Monday

Designer

Kevin J. Nyenhuis

Printing

Complete Graphics

Client

Self-promotion

Paper

80 lb. Champion Benefit Squash cover; 80 lb.
Fox River Confetti Plum cover

Kevin J. Nyenhuis, self-proclaimed director of
possibilities at Happy Monday, came up with the
idea for his sliding business card during a time
when everyone was repeating the mantra "interac-
tive new media." Even though his work is mostly
printed on paper, he decided he could still play
off the idea of interactivity. Besides, he reasoned,
in this electronic age, people need "funky little
gizmos" to play with. Engraving allowed him to print
solid on a darker stock for a more striking effect
than offset printing could have provided. The color
and contrast between the stocks and the inks, he
felt, were symbolic of the energy of his firm's work.

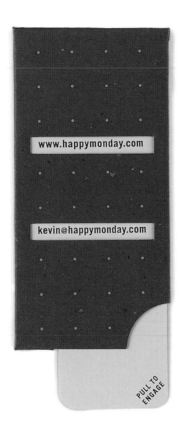

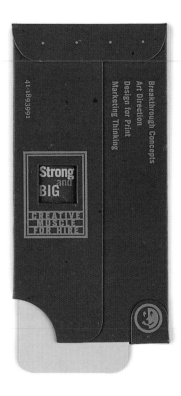

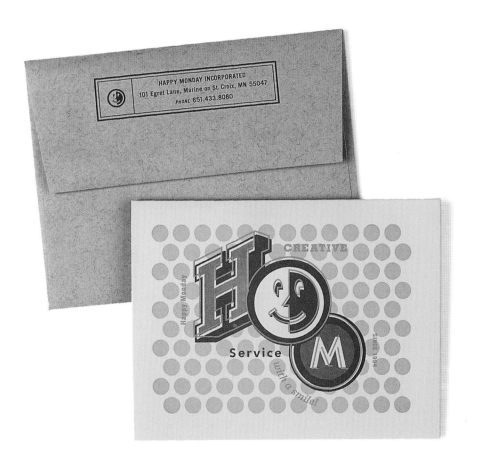

Group Baronet

Design firm
Group Baronet

Creative director
Willie Baronet, Meta Newhouse

Designer
Sarah Moriarty

Client
Self-promotion

Paper
120 lb. Signature Gloss White (cards);
110 lb. Fraser Pegasus Midnight

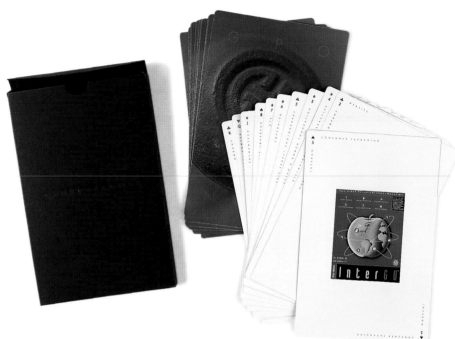

The idea for Group Baronet's oversized card deck promotion originated years ago when principal Willie Baronet and his staff were trying to think of an innovative way to do a mini-portfolio. Measuring 6 x 9-inches (15 cm x 23 cm), these giant cards can be swapped out for new samples as needed, and they can actually be played with as a deck. The paper selected had to be strong enough so the cards could be used as playing cards and had to have a surface that readily accepted four-color printing.

The idea has proved a success: The group has been invited to several pitches based on the strength of the piece alone.

Elar Partners

Design firm
SooHoo Designers

Creative and art directors
Patrick SooHoo, Kathy Hirata

Designer
Cheryl Kubo

Client
Elar Partners

Paper
11 pt. Special Card Collector Block Light stock

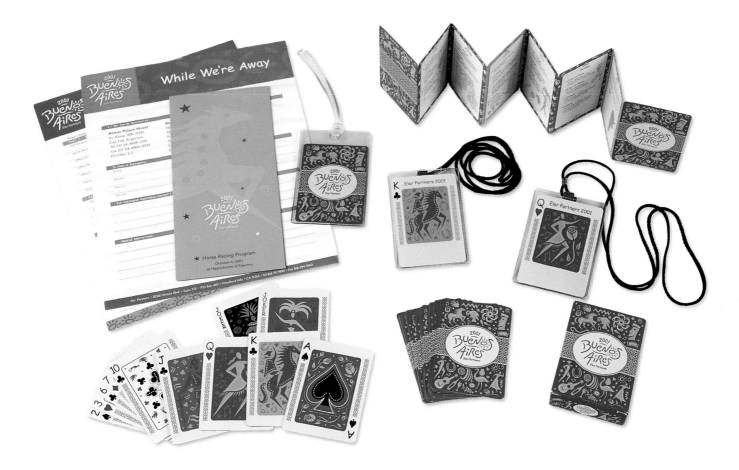

The assignment for SooHoo Designers was to develop promotional materials
for Elar Partners' sales meeting in Buenos Aires. But crucial to the job was
communicating the fun and spirit of the trip. Part of the collateral suite SooHoo
developed was an itinerary/deck of cards that reflected in color and style the
feeling of Buenos Aires: The joker is a gaucho, the queen is a flamenco dancer,
and so on. Art and creative director Kathy Hirata explains that the deck of
cards was created so that recipients could mingle and interact with one
another during various card games.

ADP Dealer Services, Canada

Design firm
Bailey Lauerman

Art director
Ron Sack

Copywriter
Bill Barna

Production
Pat Schmitt

Client
ADP Dealer Services, Canada

Paper
100 lb. McCoy Silk Cover

ADP Dealer Services Group provides integrated computing services to automotive and truck dealers throughout the United States, Canada, and Europe. Its Canadian division had a limited budget and needed to address French and English speakers in a single design. Bailey Lauerman designers devised a clever mailer that opens from its left side as well as its right—but only in one direction at one time. Readers can select the language they prefer in a single piece, meaning the client could cut its print run in half.

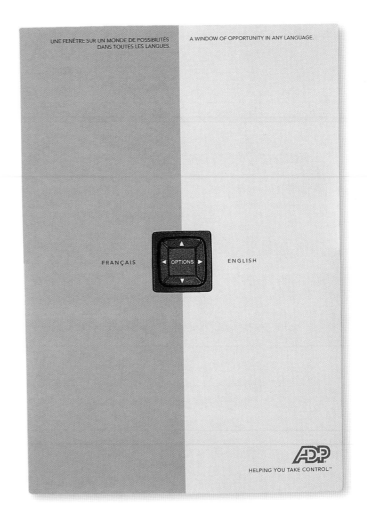

INTRODUCING ALLIANCE.™
THE FIRST BILINGUAL, WINDOWS-BASED
DEALER MANAGEMENT SYSTEM FOR
CANADIAN DEALERSHIPS.

Enhance sales, customer service and productivity throughout
your entire dealership.

It's easy with Alliance.

A remarkable new Windows® dealer management system,
Alliance puts valuable new efficiency and profit right at
your fingertips.

Track costs. Analyze trends and explore business options. Add
customers, vehicles, and suppliers to your database. Reduce
inventory and increase sales by stocking only parts that sell.

Alliance gives you that power
and more. All from the con-
venience of your desk-
top. All while working
in either French or
English (your staff can
work in both languages
simultaneously on
different workstations
throughout your dealership).

Simply point and click. Alliance's user-friendly graphical
interfaces and easy-to-follow navigations allow you to
move through daily tasks and access key information
from anywhere in the system without delay or frustration.

Easy-to-learn and easy-to-use (even if staff have no
experience in Windows-based applications), Alliance is
the important time-saving, money-making solution you've been looking
for. A system designed exclusively for the needs of Canadian dealers.

DISCOVER MORE. A FREE CD IS ENCLOSED
FOR YOUR REVIEW. FIVE MINUTES OF
INFORMATION THAT COULD HELP DRIVE
YOUR PROFITS.

Installed and supported nationwide in both French and English by
experts at ADP Canada. Completely integrated with manufacturer
software. ADP Alliance is Canada's leading dealer management
solution. Your window to increased productivity and profit.
To put it to work for you, call us toll-free at 1-866-873-7567 today.

ALLIANCE CANADA.

In any language, it means success.

ADP
HELPING YOU TAKE CONTROL.™

VOICI ALLIANCE,ᴹᴰ LE PREMIER
SYSTÈME CANADIEN BILINGUE
DE GESTION DE CONCESSION.

Haussez le niveau des ventes, du service à la clientèle et de la
productivité dans tous les secteurs de votre établissement
concessionnaire.

Rien de plus facile avec Alliance.

Remarquable nouveau système de gestion de concession pour
Windows,® Alliance met à la portée de votre clavier un niveau
supérieur d'efficacité et de profits.

Faites le suivi des coûts. Analysez les tendances et explorez de
nouvelles possibilités d'affaires. Ajoutez des clients, des
véhicules, et des fournisseurs à votre base de données. Réduisez
vos stocks et haussez vos ventes en ne stockant plus que les
pièces qui se vendent.

Alliance vous donne ce
pouvoir et beaucoup plus,
à même le bureau de
votre ordinateur, et ce,
en travaillant en
français ou en anglais
(votre personnel peut
travailler simultanément
dans les deux langues
sur différents postes de
travail de l'établissement
concessionnaire).

Vous n'avez qu'à pointer et cliquer. Les interfaces graphiques
conviviales d'Alliance et sa grande aisance de navigation

permettent de vous déplacer dans vos tâches
quotidiennes et d'accéder aux informations clés,
où que vous vous trouviez dans le système, sans
délai ni frustration.

Alliance est facile d'apprentissage et d'utilisation
(même lorsque le personnel ne possède aucune
expérience des applications pour Windows) et
constitue la solution par excellence pour gagner du temps et
hausser vos profits. Un système conçu exclusivement pour
répondre aux besoins des concessionnaires canadiens.

DÉCOUVREZ ALLIANCE. UN CD-ROM
GRATIS EST INCLUS POUR MIEUX VOUS
FAIRE CONNAÎTRE ALLIANCE. CES CINQ
MINUTES D'INFORMATIONS POURRONT
CONTRIBUER À ACCROÎTRE VOS PROFITS.

L'installation d'Alliance et les services de soutien sont assurés à
travers le pays par les experts d'ADP en français et en anglais.
S'intégrant entièrement aux logiciels du fabricant, le système
Alliance d'ADP constitue la principale solution de gestion de
concessionnaires canadiens offerte sur le marché. Votre fenêtre sur
un rendement et des profits accrus. Mettez Alliance à la tâche en
téléphonant sans frais au 1-866-873-7567 aujourd'hui même.

ALLIANCE CANADA.

Désigne le succès dans toutes les langues.

ADP
POUR PRENDRE LE CONTRÔLE.™

Quinn Evans/Architects

Design firm
Wagner Design

Creative director
Jill Wagner

Art director
Amy Zapawa

Copywriter/marketing director
Christina Breed

Client
Quinn Evans/Architects

Printer
Goetzcraft Printers

Paper
80 lb. Fox River Crushed Leaf, silver
sparkle cover (outer stock); 80 lb.
Potlatch Northwest dull cover (insert)

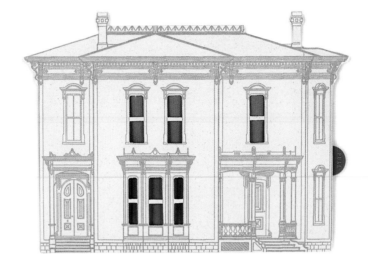

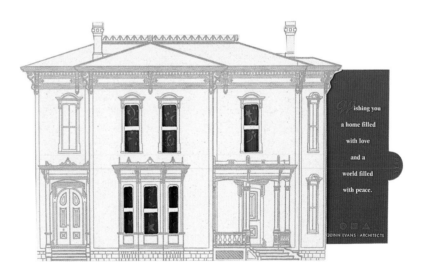

Quinn Evans/Architects is currently restoring the Capon House Museum in Grand Rapids,
Michigan, built in 1874 and listed on the National Registry of Historic Places. In 2001,
they were asked to provide a miniature model of the house for the White House Christmas
tree. Wagner Design thought the elevation on the house was a great image for its client's
holiday card: It not only worked on a marketing level, but the image of the cozy home
also acknowledged the nation's move toward nesting after the September 11 tragedy.

Leatherback Publishing

Design firm
Werkhaus

Art director
Steve Barrett

Designer
Kelly Okumura

Illustrators
Amy Hevron, Frida Clements

Client
Leatherback Publishing

Paper
130 lb. (outer cover) and 80 lb. (cards)
Fraser Pegasus White cover vellum

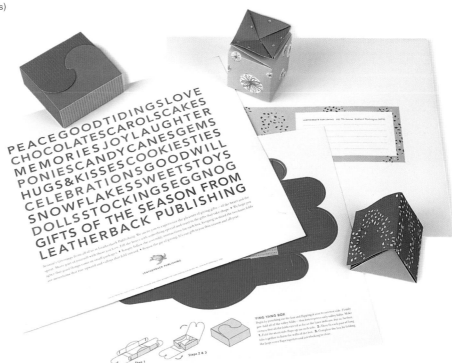

Leatherback Publishing wanted to send out a holiday promotion that showcased its printing capabilities—scoring, folding, perforating, and so on—and introduce the company to the region. These Japanese-inspired folding boxes, designed by Werkhaus, were the perfect vehicle, and they were festive and interactive as well. The Japanese aesthetic also served as inspiration for the colors. The paper stock for the boxes was selected because it demonstrates superior printing and its weight is appropriate for building boxes—thin enough to fold but heavy enough to create a usable gift box.

Start Design

Design firm
Start Design

Designer
Ian MacFarlane

Creative director
Mike Curtis

Client
Self-promotion

Paper
70 gsm bond

Start Design holds a memorable party for clients
every January. Looking to offer an excuse for
attendees to dress down for the evening at a club
named Denim, Start designers suggested on
the party invitation that they "turn up in denim."
(Turn-ups, or jeans that could be turned up at the
bottom to expose two colors of denim, were also
popular at the time.) The invitation could actually
be cut up and pinned to the attendee's clothing.
Although no one actually followed the tongue-in-
cheek instructions, everyone did show up in
jeans. Success.

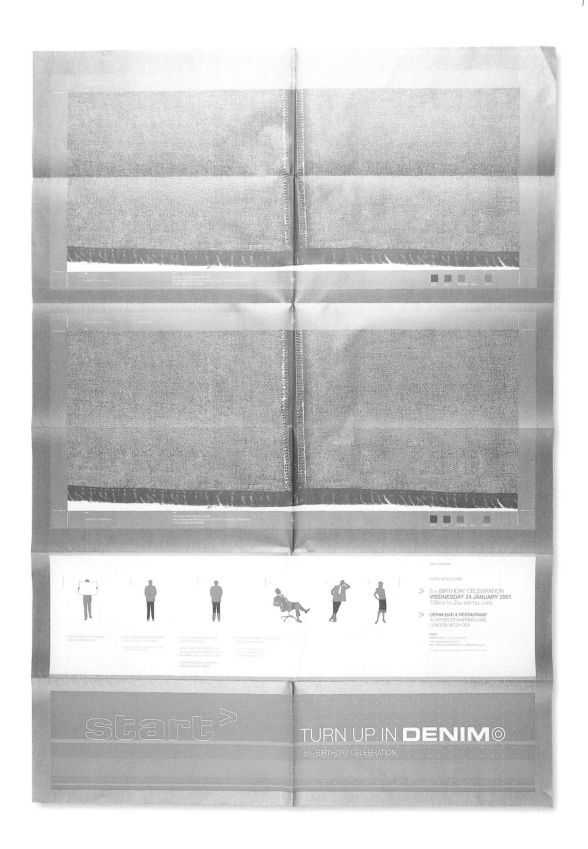

Start Design

Design firm
Start Design

Designer
Ian MacFarlane

Creative director
Mike Curtis

Client
Self-promotion

Paper
120 gsm Popset Cryogen White

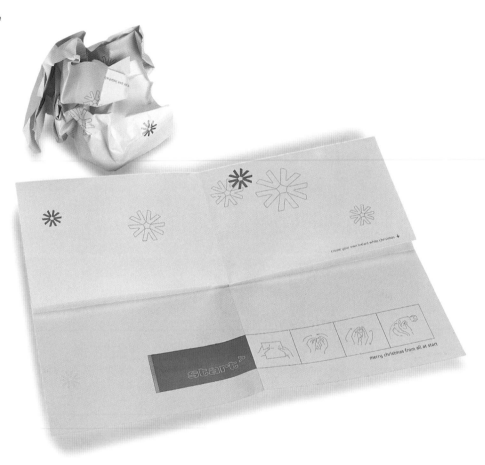

How many designers hope that recipients of their carefully crafted holiday card will crumple their design into a ball? That's exactly what those at Start Design wanted—to create a card that not only was memorable and fun but that also instantly identified Start Design as the creator. This design, printed on a shimmery white paper, is meant to be crumpled into a snowball—and about half of all recipients did exactly that. (The other half liked the card as is.)

Lee H. Skolnick Architecture + Design Partnership

Design firm
Lee H. Skolnick Architecture + Design Partnership

Photographer
© 1999 by Andrew Garn

Client
Self-promotion

Paper
43 lb. Chartham Natural Translucent Cover

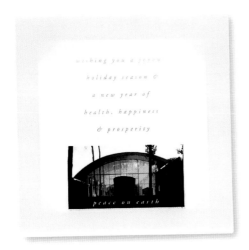

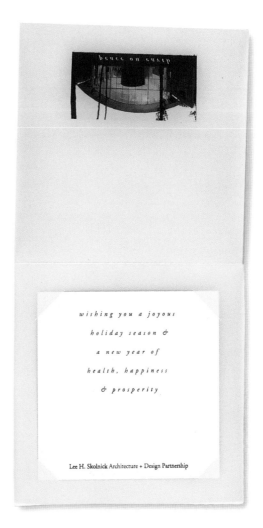

When Lee H. Skolnick Architecture + Design Partnership designers started working on the company's 2001 holiday card, they knew they wanted to use the image of a recent project—Congregation B'Nai Yisrael—and the phrase "Peace on Earth." Because vellum has a light, iridescent quality, they thought it might be an appropriate substrate for the message. The paper's translucent quality would also allow them to control the hierarchy of the messages through layering.

The key to making the color image pop off the design was placing a white card inside. The viewer first sees the image of the synagogue and the written message, and then after lifting the card's front the name of the sender, which is hidden beneath the image.

La Selva Cafe

Design firm
Burgeff Company

Designer
Patrick Burgeff

Client
La Selva Cafe

Paper
Corrugated board

Designer Patrick Burgeff invented this clever design for a coffee tray, which a local café has used for three years and which he's in the process of patenting. Four circles are kiss-cut in the center of a piece of corrugated cardboard. Each punch-out has a slash cut into its edge. Once removed, the notched circles can be fitted onto matching slits on the edge of the main board, creating legs for the takeaway tray. Coffee cups fit right into the holes in the middle of the cardboard oval, and the circular legs keep the entire structure stable.

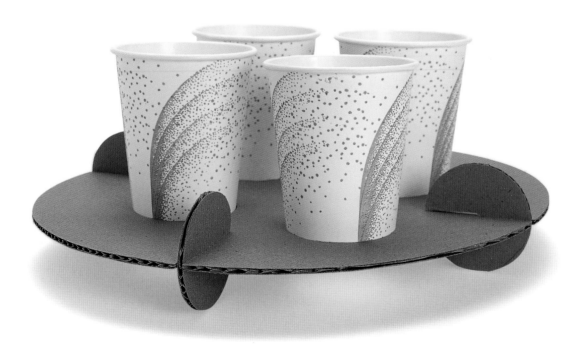

Dimensional Paper

CHAPTER 2

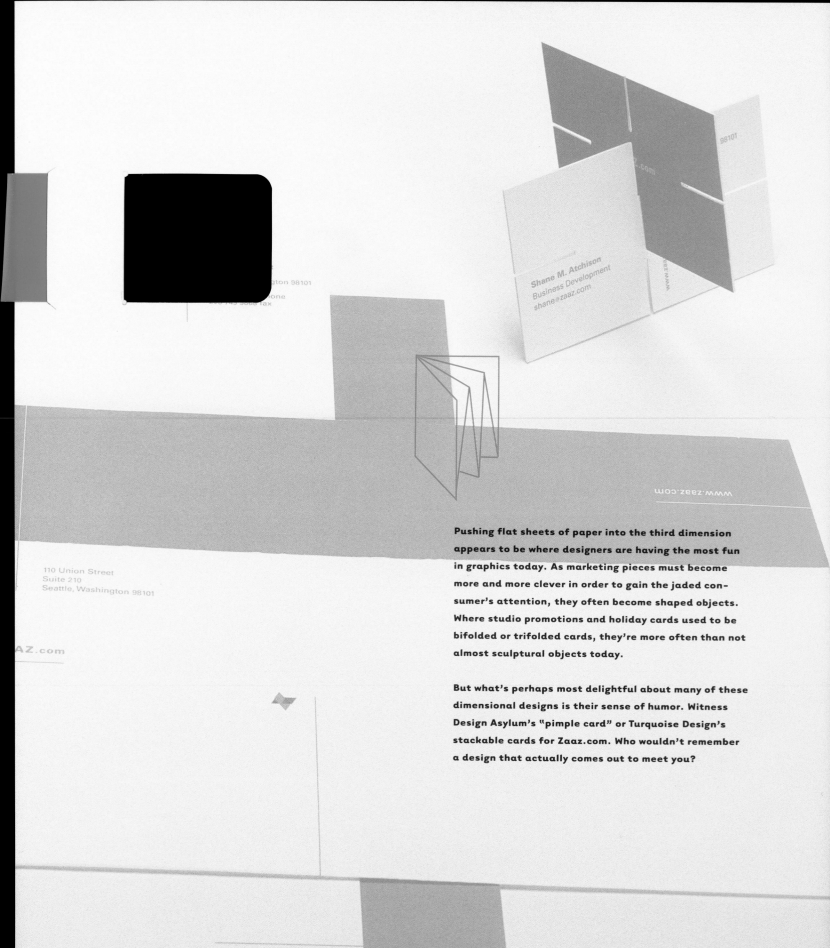

Shane M. Atchison
Business Development
shane@zaaz.com

98101

www.zaaz.com

110 Union Street
Suite 210
Seattle, Washington 98101

AZ.com

www.zaaz.com

Pushing flat sheets of paper into the third dimension appears to be where designers are having the most fun in graphics today. As marketing pieces must become more and more clever in order to gain the jaded consumer's attention, they often become shaped objects. Where studio promotions and holiday cards used to be bifolded or trifolded cards, they're more often than not almost sculptural objects today.

But what's perhaps most delightful about many of these dimensional designs is their sense of humor. Witness Design Asylum's "pimple card" or Turquoise Design's stackable cards for Zaaz.com. Who wouldn't remember a design that actually comes out to meet you?

John Sharpe

Design firm
Templin Brink Design

Client
John Sharpe

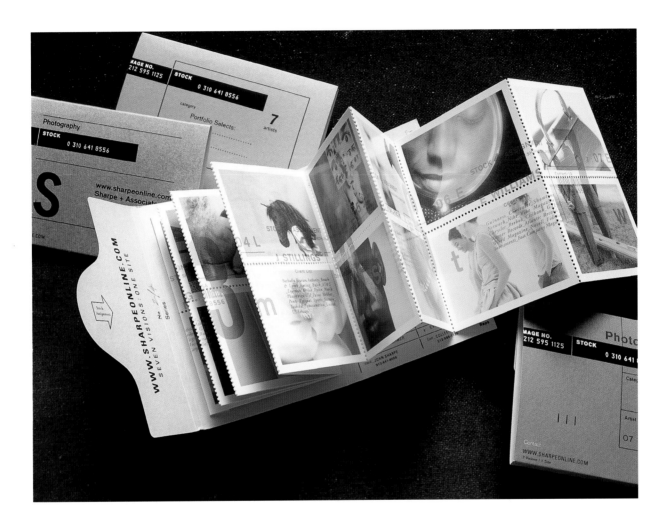

Like any rep, John Sharpe is constantly faced with how to regularly promote the creatives with whom he works. He also wanted to drive traffic to his new Web site. Templin Brink Design had a simple answer: The firm created a small, tactile design that was inexpensive to produce—about $1 per package—but still had plenty of images that could easily be updated for quarterly mailings. At 4 x 2 5/8-inches (10 cm x 6.5 cm), principal Joel Templin says they've discovered that the mailers are so precious to recipients that even if they aren't ready to buy stock or commission new work, they'll stow the mailer in a drawer for future reference.

Trickett & Webb

Design firm
Trickett & Webb

Pin
REV Gomm

Paper
Zanders Zeta Hammer, brilliant white 350 gsm

Years ago, Trickett & Webb (T&W) designed a pin for a client—and T&W's own designers fell in love with the tiny medium. Over the years, T&W has produced many pins, including some for its holiday mailers. The idea came about as a result of an office competition. The only stipulation is that "T&W" must appear somewhere on the design.

The pin for 2001 meets that requirement, plus it has an appropriately cozy sense for the season. It was put to bed—literally—in a soft, linen-like paper. Turning down a corner completes the illusion of a comfortable, warm bed. "I think the thing about folding and working with paper is that you need to think in 3-D, which isn't so easy on a 2-D computer screen," says principal Brian Trickett. "We like the tactile quality of paper, so it tends to be an integral part of each project."

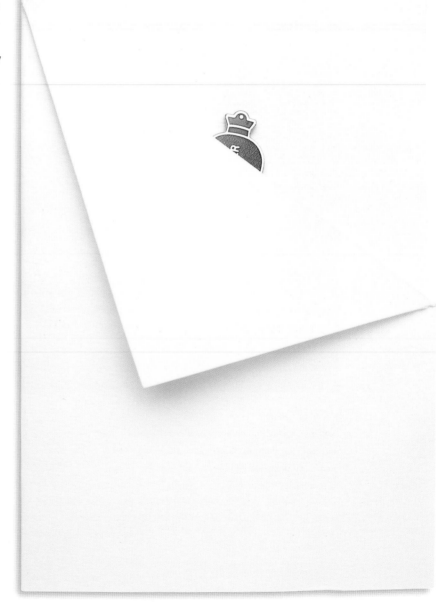

Peter Felder

Art director, designer
Peter Felder

Writer
Paulo Coelho

Printer
Johannes Thurnher/Rankweil

Paper
135 g/m Gmund Color

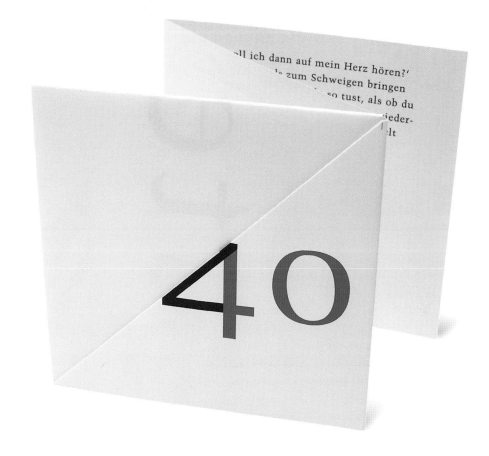

Designer Peter Felder created this unique, unfolding birthday party invitation for his friend Ingrid Holzmuller's celebration. Knowing that Ingrid is a fan of writer Paulo Coelho, he excerpted text from Coelho's book *The Alchemist*. Then, with a few clever folds and a typographic sleight of hand, he created a card that was both memorable and meaningful. The invitation gatefolds out conventionally to its center, and then a single diagonal fold causes the design to turn the corner.

Aspen Traders

Design firm
Gardner Design

Designers
Bill Gardner (3-D folds); Chris Parks (surface design
on Moroccan card); Brian Miller (surface
design on other cards)

Client
Aspen Traders

Paper
Various

For 17 years, Gardner Design has created
extraordinary 3-D Christmas cards for Aspen
Traders, a successful store that carries clothing,
jewelry, and bath and home accoutrements. The
cards are designed to defy gravity and never land
in the trash, says principal Bill Gardner. What's
more, they require no assembly: Just pull them
from the envelope and admire. The cards'
graphics are based on the hot trends for the year:
mosaic tiles, angels, tattoos, Mexico, the lushness
found in the movie *Moulin Rouge*, and so on.

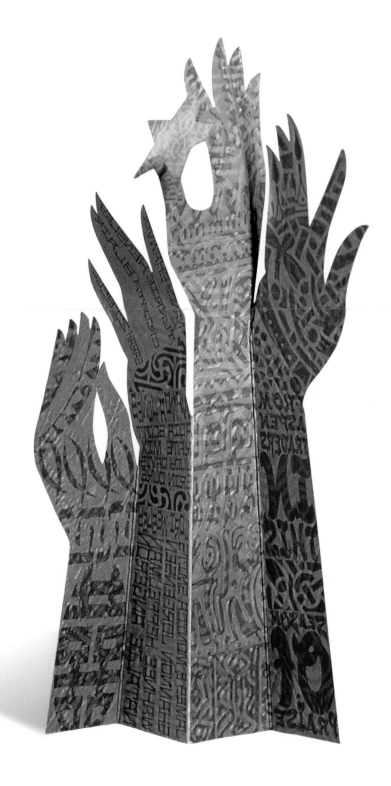

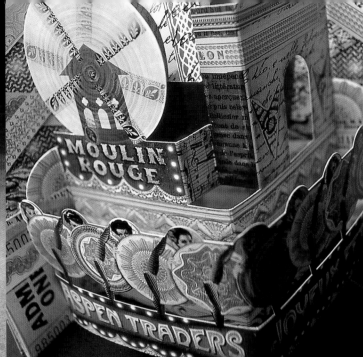

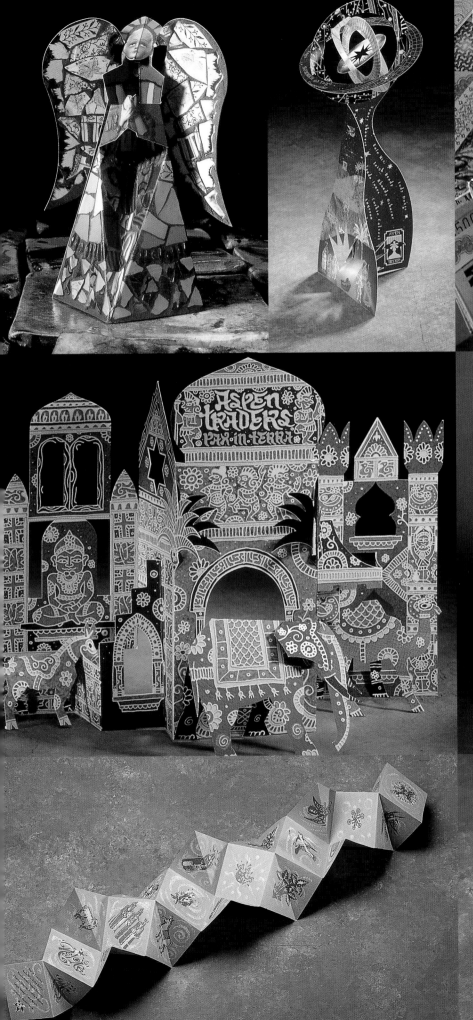

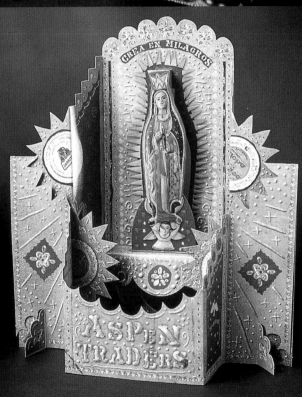

ASPEN TRADERS
Kate Mix, Judy Davis,
Nanda Jones, Nancy Shawver,
Rhonda Osborne, Natalie Angeron,
Leigh Brady, Cindy Rinck,
Monica & James Smits

SK Designworks, Inc. and Channel 13/WNET

Design firm
SK Designworks, Inc.

Designer
Soonduk Krebs

Client
Self-promotion (Carb) and Channel 13/WNET (Egg)

Paper
Curtis Corduroy for box and handmade paper for pasta wrap (Carb); Fraser Paper Outback (Egg)

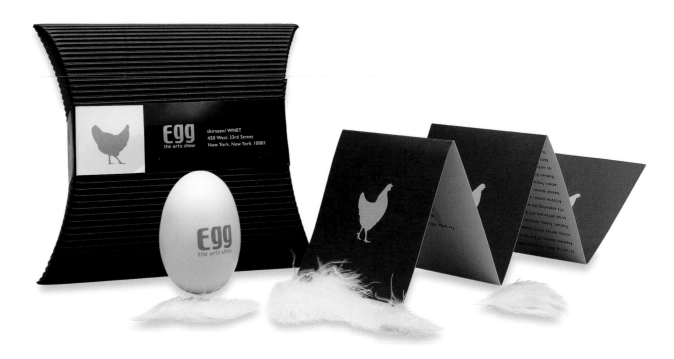

Pillow mailers can be used for various purposes and effects, as designer Soonduk Krebs of SK Designworks shows with these samples. The Divine Carb, a self-promotional holiday mailer, contains pasta wrapped in handmade paper. Here the pillow provides protection for the package's contents. For the Egg mailer, the pillow provides a shape that can't help but spark curiosity in the mind of the recipient. In both cases, Krebs achieves structural stability and visual interest.

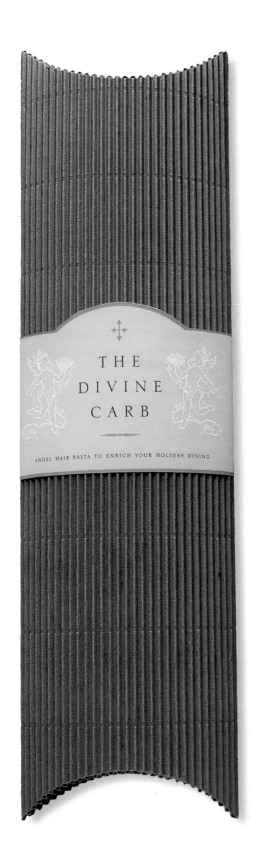
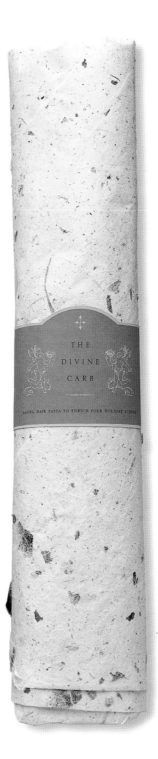

Liechty/Meyer Family

Design firm
Meyer & Liechty, Inc.

Designers
Hailey Meyer, Christopher Liechty

Client
Liechty/Meyer Family

Paper
80 lb. Strathmore Script Smooth cover

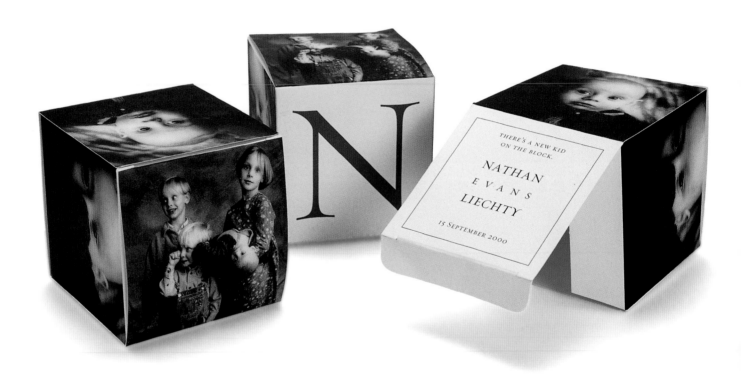

When Christopher Liechty and Hailey Meyer had their fourth child, a son, they named him Nathan, which means "gift." To announce his birth, they wanted to give friends and family their own gift. So Meyer created a small cube with photos of her children on all sides and the sly headline, "There's a new kid on the block." The couple hopes that the design, which mails flat, is one that recipients will keep on display in their homes for a long time.

They also had this kind of success with their daughter Stella's birth announcement, which was made into the shape of a table tent—a ready-made frame with preinserted photo.

M.C. Ginsberg

Design firm
Sayles Graphic Design

Art director and designer
John Sayles

Client
M.C. Ginsberg

Paper
Corniche Matte White

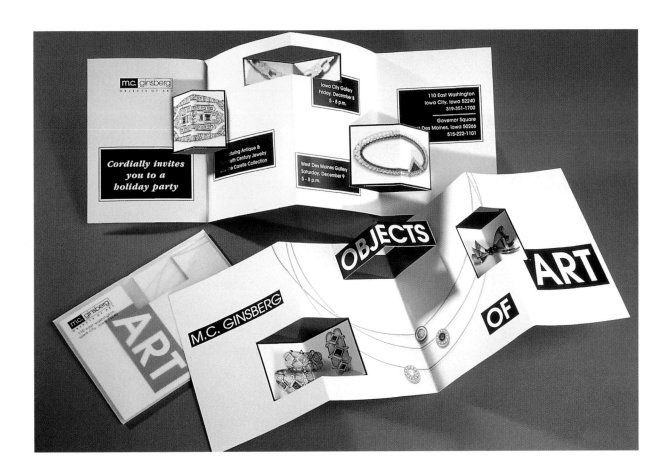

Here's how to transform a standard trifold or quadfold brochure into an outstanding showpiece: Sayles Graphic Design added several carefully placed diecuts and strikes to create what almost looks like shelves or showcase space for this jewelry client. Because Ginsberg's products are so unusual, says Sayles principal Sheree Clark, they felt it was crucial for this gallery invitation to have the same flair.

Paragon Trade Brands

Design firm
Knauf & Associates, Inc.

Creative director
Ken Knauf

Designer
Siriwan Hiranlertprasert

Illustrator
Mark Slawinski

Client
Paragon Trade Brands

Paper
8 pt. Carolina C2S cover

Knauf & Associates' client, Paragon Trade Brands, asked the design firm to create a collateral piece that would remind their customers of the launch of a new premium diaper product: Earlier efforts had been disappointing. The vehicle had to have a premium look, educate the sales force and customer about the product, hold a product sample, ship flat, fit easily inside a salesperson's briefcase, and keep production costs to a minimum. Knauf's solution was a pillow mailer with a twist: The front cover swings open, making product information immediately accessible, without hiding it inside. The unique design allows the packaging to be kept flat until the product is inserted, and it keeps the enclosed diaper pristine until the recipient chooses to handle it.

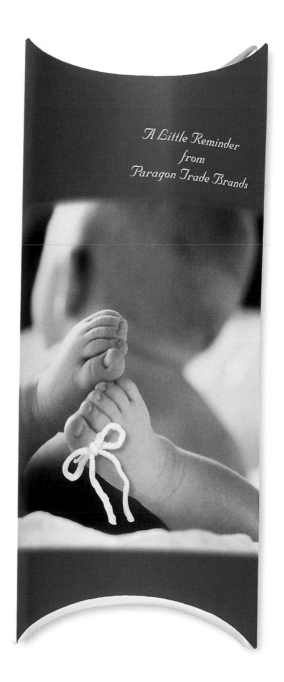

A Little Reminder
from
Paragon Trade Brands

A better fitting diaper is coming your way

Our new diapers will provide better fit and comfort for baby with great new features moms prefer. The wider chassis will provide an improved fit at the waist. In fact, Moms rated Paragon's Ultra 6 diaper "Better Overall Fit" compared to Huggies® UltraTrim™.

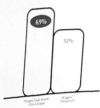

69%

52%

Paragon Trade Brands Ultra 6 Diaper

Huggies® UltraTrim™

Overall Fit % Just Right Responses

Base: (108) respondents

Ultra 6 vs. Huggies® UltraTrim™ Defrass Technologies, Inc. July 2000

The newly designed stretchable tab shape has less contact with baby's sensitive skin, making baby more comfortable. And now the loop is printed on the waist panel with new playful patterns for an improved appearance.

We have also improved our core design, which has an even better rewet performance. The new process redistributes the super absorbent polymer for greater absorbency where baby needs it the most. The new core is wrapped with tissue and has a new shape. The result is increased pad stability and significantly improved rewet!

Moms will be happy to know our diapers still have the same great features they have come to expect, such as an absorbent core, cloth-like cover, stretch waist, and a perfume and dye free liner.

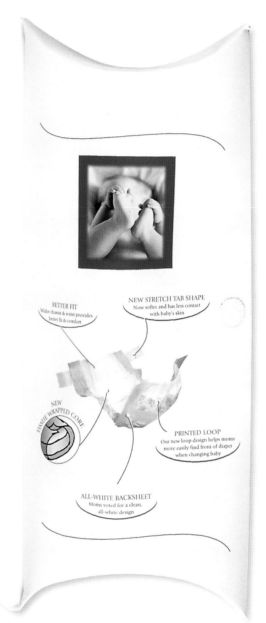

BETTER FIT
Wider chassis & waist provides better fit & comfort

NEW STRETCH TAB SHAPE
Now softer and has less contact with baby's skin

NEW TISSUE WRAPPED CORE

PRINTED LOOP
Our new loop design helps moms more easily find front of diaper when changing baby

ALL-WHITE BACKSHEET
Moms voted for a clean, all-white design

Ford & Earl Associates

Design firm
Ford & Earl Associates

Art director
Bonnie Zielinski

Designer, illustrator
Robin Olson

Client
Self-promotion

Paper
40 lb. GilCear Heavy White

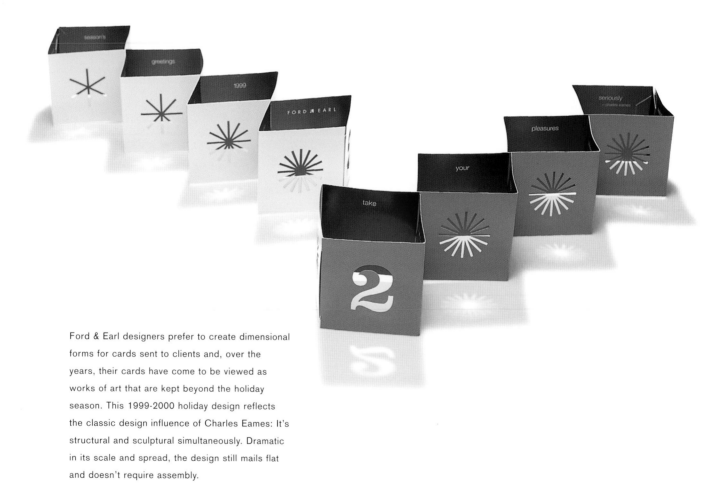

Ford & Earl designers prefer to create dimensional forms for cards sent to clients and, over the years, their cards have come to be viewed as works of art that are kept beyond the holiday season. This 1999-2000 holiday design reflects the classic design influence of Charles Eames: It's structural and sculptural simultaneously. Dramatic in its scale and spread, the design still mails flat and doesn't require assembly.

Target Corporation

Design firm
Wink

Art directors
Scott Thares, Richard Boynton

Designer, illustrator
Scott Thares

Client
Target Corporation

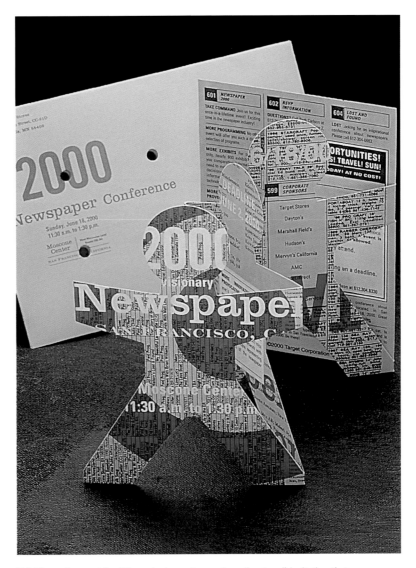

Wink's assignment for this project was to create a direct-mail invitation that was specifically targeted at "newspaper people." The idea was to increase attendance at an annual Target-sponsored event, held during a newspaper conference. Wink designers thought they would speak in the invitees' own language: They created this tribe of newspaper cutout people, overprinted with detailed conference information.

Lippa Pearce Design

Design firm
Lippa Pearce Design

Art director
Harry Pearce

Designers
Harry Pearce, Pete Ramskill

Client
Self-promotion

Paper
Phoenix Motion stock; composite board

This design, titled "All I want for Christmas," is a card that Lippa Pearce Design sent out to clients and friends for the holidays. It's a mixture of hand folding and mechanical folding and of rough and smooth materials. The rough composite board cover provides a nice contrast against the smooth paper inside. Even the difference in paper weights creates instant interest. On the cover, Lippa Pearce designers created another spot of contrast: The teeth are debossed with a white silkscreen finish.

Zaaz.com

Design firm
RMB Vivd

Art director
Brian Boram

Designers
Brian Boram, Misha Zadeh

Client
Zaaz.com

Paper
70 lb. and 240 lb. (two layers of 120 lb.
pasted together) Starwhite Tiara Vellum
finish text

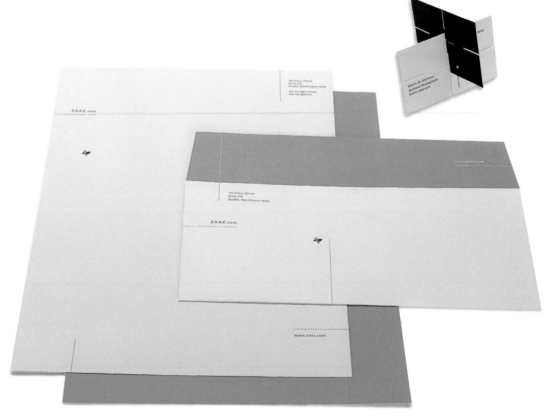

Zaaz.com wanted an identity that really set it apart
from other brand-new, band-end Web design
companies. The company's second, more unusual
request: thick business cards. RMB Vivid took up
the challenge. Its designers created interlocking
cards that have a bold, clean architectural look and
that are as interactive as the company itself in that
they can be fitted together. This turns out to be an
irresistible pastime: For instance, at the company's
open-house party, the employees held a contest to
build the coolest structure out their cards.

Greg Herr, Haberdasher

Design firm
Stone & Ward

Creative director
Larry Stone

Art director
Bill Jennings

Associate art director, illustrator
Takako Yagai

Print production
Brenda Fowler

Client
Greg Herr, Haberdasher

Paper
24 lb. Neenah Classic Crest, Avon Brilliant white

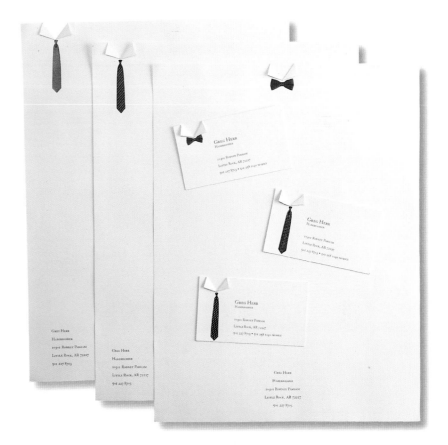

Shortly after accepting the Greg Herr Haberdasher stationery project, Larry Stone of Stone & Ward was sitting in a rather dull meeting. He began to doodle and drew a man's tie near the top of his sheet of notepaper. He put down his pen, ripped the paper down to meet the top of the tie, folded the two sides of the newly created collar back, and he had found his solution, all in less than two minutes. Today, the client still cuts and folds each piece by hand to keep costs down, and the compliments continue to roll in.

Peggy Chan

Design firm
Design Asylum

Art director, designer
Christopher Lee

Client
Peggy Chan

Paper
250 gsm Consort Royal Silk

One side of this business card is graphic and
somewhat abstract wheras the other side is
highly descriptive and concrete. Created for an
aesthetician/beautician, the side of the card that
displays the professional's information feels
contemporary and polished: A deboss adds a
subtle, modern pattern. The other side carries
the emboss: The tiny raised dots convey the
idea of blemishes and pimples in a tasteful,
witty manner. The paper choice was important
to the success of the design because it had to
evoke a quality feel, yet be able to carry the
emboss and deboss in a gentle way.

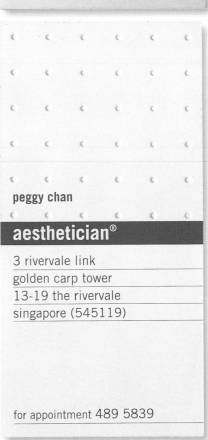

Payard Patisserie & Bistro

Design firm
Sharp Communications, Inc.

Art director
Anri Seki

Designers
Anri Seki, Ji-won Choi

Copywriter
James Brodsky

Printer
Peachtree Enterprises, Inc.

Client
Payard Patisserie & Bistro

Paper
80 lb. Fox River Sundance cover, Country Cream

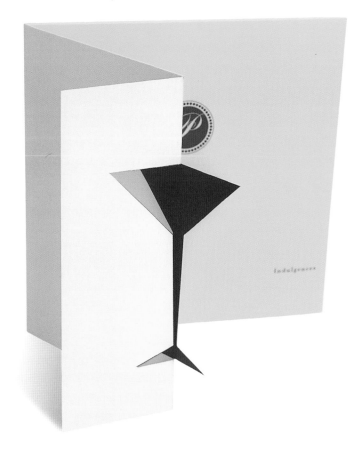

Payard Patisserie & Bistro, owned by celebrity chef
François Payard, was trying to reach a young,
glamorous, high-net-worth audience to introduce a
line of cocktails and late-night menus. Payard
asked Sharp Communications to create an invita-
tion to a special event that would—if successful—
host New York's leaders in fashion, style, and
media. Art director Anri Seki used the colors of
crème, butter, and chocolate to reference Payard's
renowned dessert masterpieces. She then added
the swinging cocktail glass cutout, a clean, modern
touch that was neither too fashion-forward nor
candy-like. The invitation pulled well: More than
300 of New York's style leaders attended.

Frost Design

Design firm
Frost Design

Art director
Vince Frost

Client
Self-promotion

Paper
Recycled compressed board

The idea for the format of this curiously shaped
self-promotional mailer came from the paper fan.
Principal Vince Frost spent seven months living
in Japan and was fascinated with the way the
Japanese used paper. For the purposes of this
promotion, he wanted to show a lot of work
without a lot of words. This format did the trick:
Its shape is interesting, and its folds form an
actual grid that organizes plenty of work samples,
so words really became unnecessary.

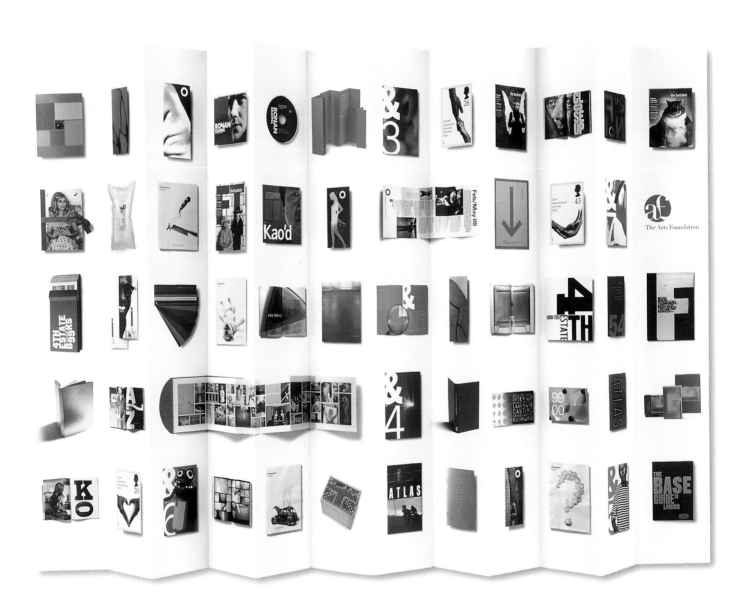

ƐON

NO3

Design firm
Frost Design

Designers
Vince Frost, Sonya Dyakova

Client
EON

Paper
Recycled beer label stock

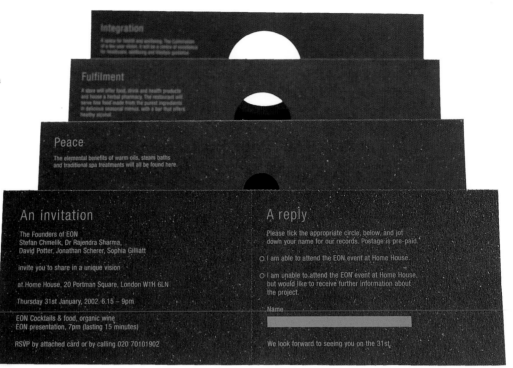

Integration

A space for health and wellbeing. The Collonade is a two-year vision. It will be a centre of excellence in healthcare, wellbeing and lifestyle products.

Fulfilment

A store will offer food, drink and health products and house a herbal pharmacy. The restaurant will serve fine food made from the purest ingredients in delicious seasonal menus, with a bar that offers healthy alcohol.

Peace

The elemental benefits of warm oils, steam baths and traditional spa treatments will all be found here.

An invitation

The Founders of EON
Stefan Chmelik, Dr Rajendra Sharma,
David Potter, Jonathan Scherer, Sophia Gilliatt

invite you to share in a unique vision

at Home House, 20 Portman Square, London W1H 6LN

Thursday 31st January, 2002. 6.15 – 9pm

EON Cocktails & food, organic wine
EON presentation, 7pm (lasting 15 minutes)

RSVP by attached card or by calling 020 70101902

A reply

Please tick the appropriate circle, below, and jot down your name for our records. Postage is pre-paid.

○ I am able to attend the EON event at Home House.

○ I am unable to attend the EON event at Home House, but would like to receive further information about the project.

Name

We look forward to seeing you on the 31st.

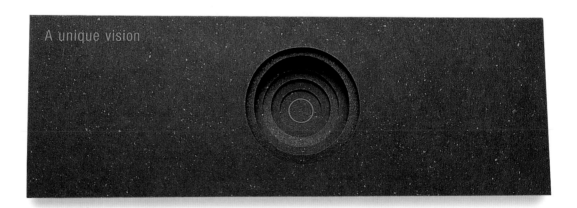

A unique vision

Eastern Oriental Natural, or EON, is a new holistic center in London that will be opening in 2003. Its 50,000 square feet (4,645 square meters) will offer a wide selection of well-being practices, such as exercise classes and healthy-eating options. For an event meant to attract potential investors, Frost Design created an unusual invitation: an accordion-folded piece that is diecut with progressively smaller holes. The holes not only create intrigue and visual interest, they also work with the title of the piece, "Unique Vision," and the idea that a circle is a symbol for being centered and complete. The client reported that the invitation was the most effective one they had ever sponsored, pulling in an 85 percent turnout.

Ford & Earl Associates

Design firm
Ford & Earl Associates

Art director
Bonnie Zielinski

Designer, illustrator
Robin Olson

Client
Self-promotion

Paper
120 lb. Strobe Gloss cover

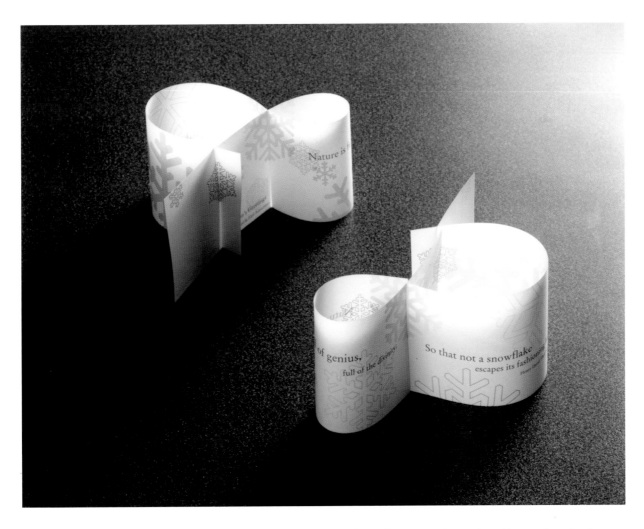

Capture in dimensional form the essence of the design process. Deliver an interactive message in a sculptural form so it can be displayed, viewed, and valued beyond the immediate holiday. Create a holiday "gift" card that conveys how strongly you value your clients. All were objectives for Ford & Earl Associates' designers in creating the firm's 2000-2001 holiday card. In its final form, the sculptural card creates an ampersand, an integral part of the firm's brand mark and a universal symbol of creativity. It can stand either horizontally or vertically.

Finished Art, Inc.

Design firm
Finished Art, Inc.

Creative directors
Donna Johnston, Kannex Fung

Designers, illustrators
Barbara Dorn, Luis Fernandiz, Kannex Fung,
Li-Kim Goh, Mary Jane Hasek, David Lawson,
Rachele Mock, Sutti Sahunala, Linda Stuart

Client
Self-promotion

Paper
Various metallic papers

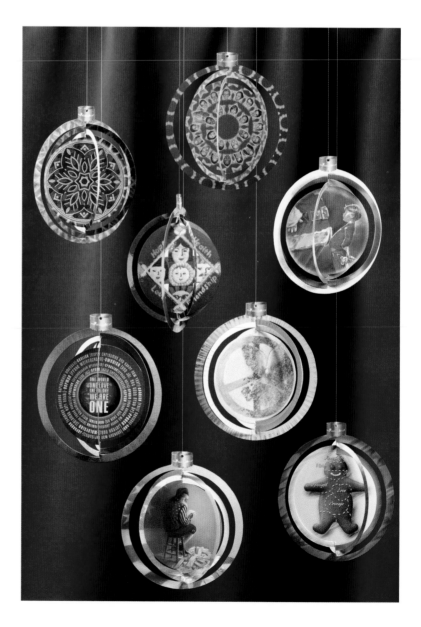

Finished Art, Inc., sent a set of ornamental
greetings to clients in December 2001. Original
art that studio artists created was featured on
each side of four diecut panels and printed on
metallic paper that give the illustrations a subtle
glow. The panels were designed with alternate
folds that allowed the panels to be hung as a
sphere, which revealed both sides of each
design. There is no right or wrong way to fold
the circles, so recipients can create their own art.

Finished Art, Inc.

Design firm
Finished Art, Inc.

Creative directors
Donna Johnston, Kannex Fung

Designer
Kannex Fung

Illustrator
Luis Fernandez

Copywriter
Barbara Born

Client
Self-promotion

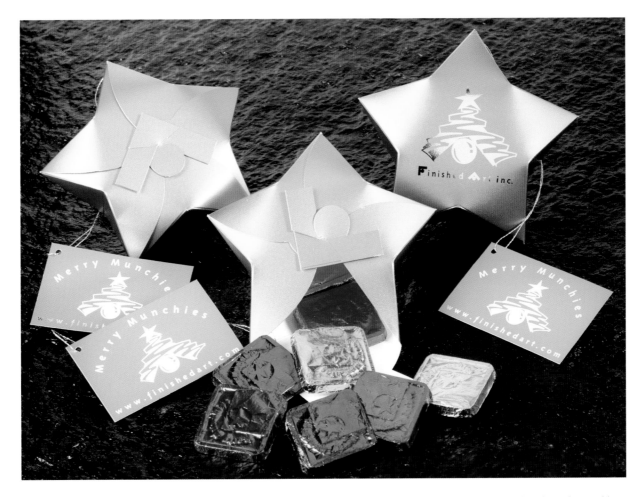

The challenge for this self-promotional project was to create a unique box that initially contained customized gift chocolates, but could later be kept as an ornament. Designers from Finished Art, Inc., tested many possible constructions. Finally, they selected a design that kept production costs low and didn't require gluing. The interlocking mechanism on top forms the company logo. There was one problem, however: The logo was destroyed when the recipient opened the little gift. The solution was to change one interlocking flap to be an opening, which allowed the design to be used as both a box and later as an ornament.

Museum of Shenendoah Valley

Design firm
Beth Singer Design

Client
Museum of Shenendoah Valley

Paper
70 lb. Graphika Lineal Chalk text

How does one send out an invitation? In an
envelope, right? Designers at Beth Singer Design
were looking for a way around that tired solution
in an invitation they created for a Museum of
Shenendoah Valley opening. Playing off the
word *opening*, they created a new solution:
accordion-fold the invitation in a box. The recipient
can't help but open the little present, and the
message is cleverly delivered on a toothy,
somewhat rustic paper.

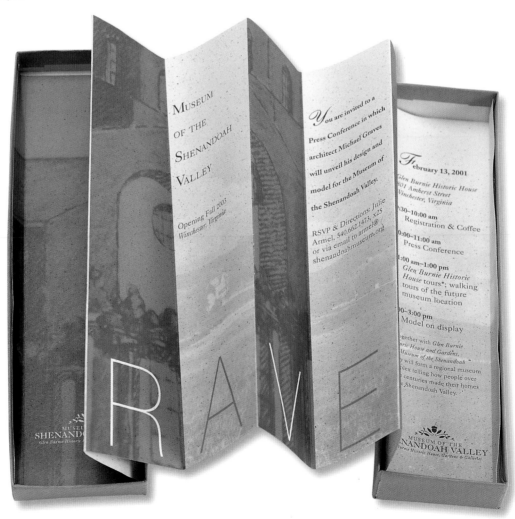

Naked Paper

CHAPTER 3

2002

ENE	FEB	MAR
ABR	MAY	JUN
JUL	AGO	SEP
OCT	NOU	DIC

This section features what might be the most diffi-
cult sort of design—relying entirely on the paper to
get the job done. Because paper is so malleable, it
can be cut, stamped, folded, and even ripped into
the desired form. But a strong concept and a coop-
erative print partner are keys to success here.

The transparent date books shown here are an
excellent example of how paper can actually be the
entire message. Designer Patrick Bergoff specified
transparent paper for a familiar design—date-
books—because it allowed the user to physically look
forward and backward into design.

Bull Rodger

Design firm
Bull Rodger

Designers
Andrew Rodway, Emma Faulkner

Production
The Tower Printing Company

Client
Self-promotion

Paper
Arjo Wiggins Conqueror Contour, Brilliant White, 300 gsm

Paul Rodger, founder of the London-based design and copywriting firm Bull Rodger, calls this design, "probably the most minimal thing we've ever done." Except for a Web site address printed in the most subtle silver-gray on its reverse side, the card is blank on its outside. Inside, in the same silvery ink, barely there, are the words, "White Christmas card from Bull Rodger."

Says Rodger, "The design relies completely on the choice of paper for its effect, which was to look like snow."

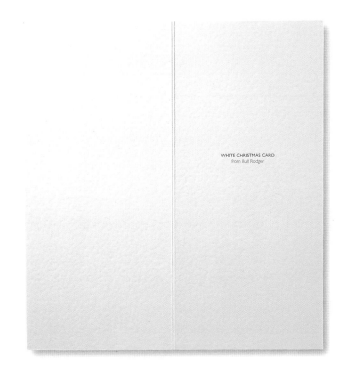

WHITE CHRISTMAS CARD
from Bull Rodger

Parham Santana

Design firm
Parham Santana

Creative directors
John Parham, Maruchi Santana

Art director
Maryann Mitkowski

Printer
PrintIcon (NY)

Client
Self-promotion

Paper
110 lb. Strathmore cover, Ultimate White

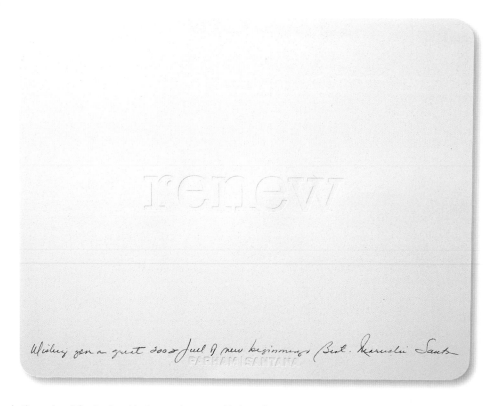

In the wake of September 11, the word on many Parham Santana staffers' lips for the firm's one-word holiday card was *peace*. But they wanted to say even more: forward motion, action, accomplishment. They wanted to head in the opposite direction of destruction. Searching dictionaries, quizzing loved ones, and scanning newspapers led them to words like *rebuild, restore,* and *renew.* With its connotation of rebirth and moving forward, *renew* was the clear winner.

In its execution, simplicity was key. The typeface Clarendon was selected for its balance of humanity and strength. The blind emboss on pure white cover stock communicates an understated joyfulness—simple, clear, hopeful.

Burgeff Company

Design firm
Burgeff Company

Designer
Patrick Burgeff

Client
Self-promotion

Paper
Various translucent papers

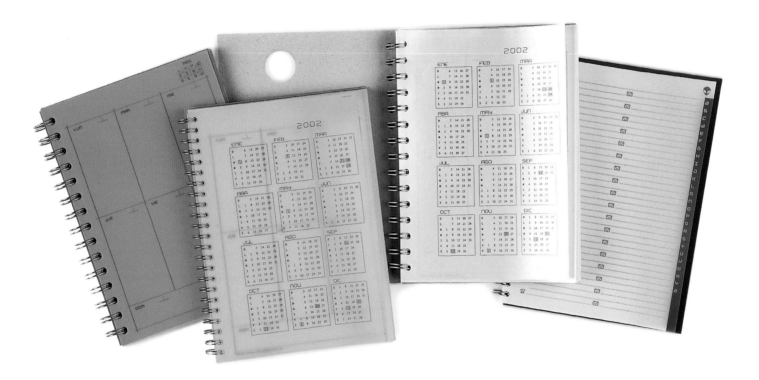

Patrick Burgeff's unusual datebooks have several metaphorical aspects. First, the designer selected different colors of paper for various books. Dynamic colors energize people during their working hours, he says, whereas soft colors are necessary for quieter times. Both aspects are needed. Second, he selected translucent papers that allow the user to see the past and the future simultaneously throughout the year. The translucence allows time to flow continuously, in a graphic sense.

CDT Design Ltd.

Design firm
CDT Design Ltd.

Creative director
Iain Crockart

Client
Self-promotion

Paper
300 gsm and 150 gsm Hannoart Silk

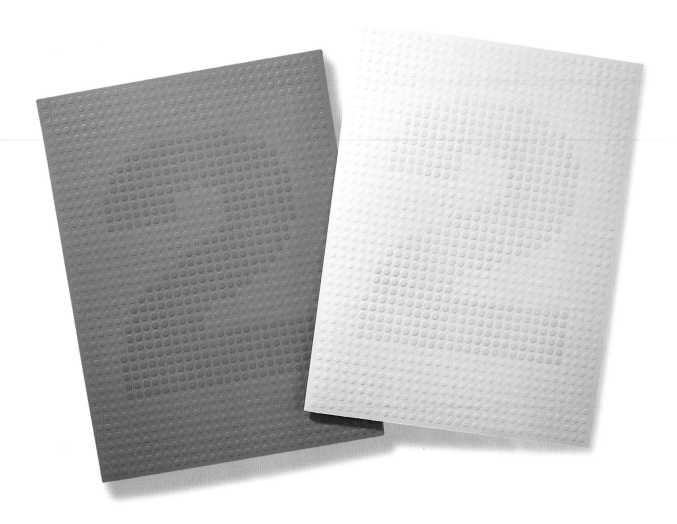

CDT published its first portfolio book in 1993; the (orange) book shown here is its second published portfolio, released in December 2001. As the books are sold on the retail level, CDT designers want them to have a highly tactile quality, making the experience of handling the book more interesting. To achieve this decidedly touchable effect, an embossed pattern of dots, first printed in orange, was overprinted with the same color a second time to create the numeral 2.

VaxGen

Design
Vinje Design

Art director, designer
Andreas Keller

Illustrator
Neil Brennan

Printer
Bofors Lithograph

Client
VaxGen

Paper
100 lb. Mohawk Navajo Double Thick Cover, Brilliant White

Getting readers up close and personal with the AIDS virus was the goal for creatives at Vinje Design. Two dies—one striking from the top and one striking from the bottom—were key to creating this unusual sculptural effect. Some experimentation was required on press to discover just how much stress the paper would take.

Making the virus and antibodies (added later at the client's request) tangible was all the art that the VaxGen annual report needed. "We wanted people to be aware that everyone can be in touch with the AIDS virus. It isn't just a problem for prostitutes and people in Africa," says art director Andreas Keller.

Crosetti/Thomas Families

Design firm
Scott Wallin Design

Art director, designer
Scott C. Wallin

Client
Crosetti/Thomas Families

Paper
Glamalope text (various colors)

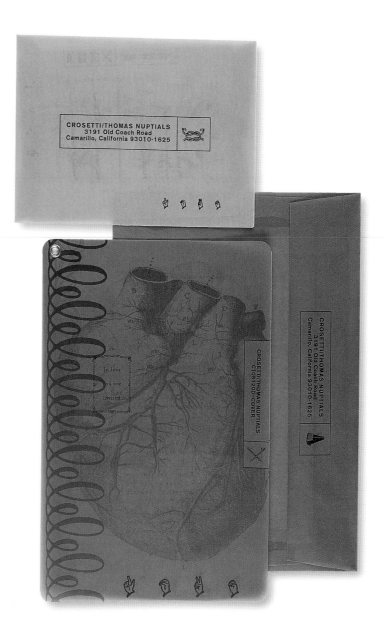

Designer Scott Wallin is close to both the bride and groom for whom this unique wedding invitation was created, and it was with their blessing that he created a design that held no preconceived ideas of what such a document should look like. The couple provided Wallin with lots of visual inspiration, ranging from things that were dear to them to images they thought were cool or pretty. The designer distilled these down to a collection that was both visually and conceptually stimulating. Then he reproduced the images and added text on layers of colored vellum, representing the many layers of the couples' personalities. Yes, the couple got feedback from recipients: Younger guests loved it, but older attendees said that even though they didn't "get it," they appreciated the fact that the invitation was unconventional and fun, just like the couple.

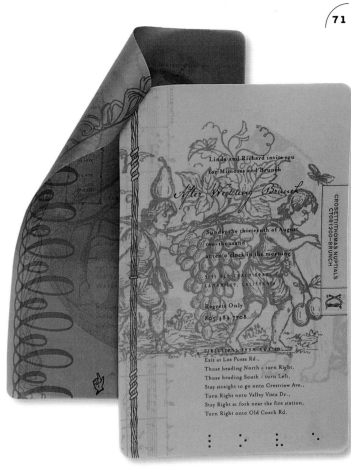

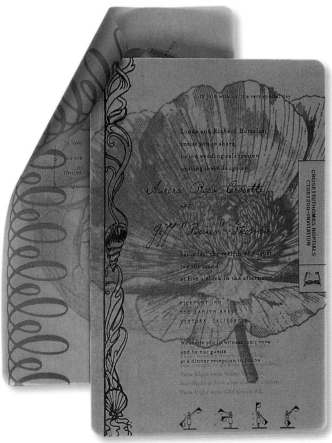

Sydney Banks Insititute for Innate Health

Design firm
Adams Advertising

Creative director
Rob Jackson

Client
Sydney Banks Insititute for Innate Health

Paper
12 pt. Mirricard silver cover

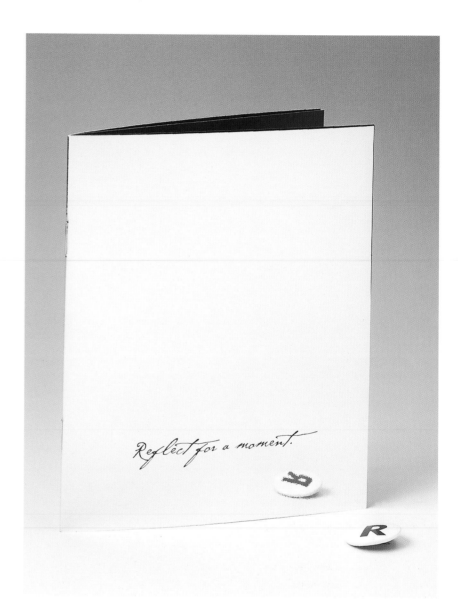

Reflective paper stock is the hero of this piece. An invitation to a dedication ceremony for the Sydney Banks Institute for Innate Health at West Virginia University, the card drew on the organization's teachings. Insight and the ability of each individual to look within himself are central to its message. The paper allowed the designer to communicate that to a distinguished audience in a simple, eloquent manner.

London School of Business

Design firm
Lippa Pearce Design, Ltd.

Art direction
Dominic Lippa

Designers
Rachael Dinnis, Joke Racsh

Client
London School of Business

Paper
300 gsm Accent

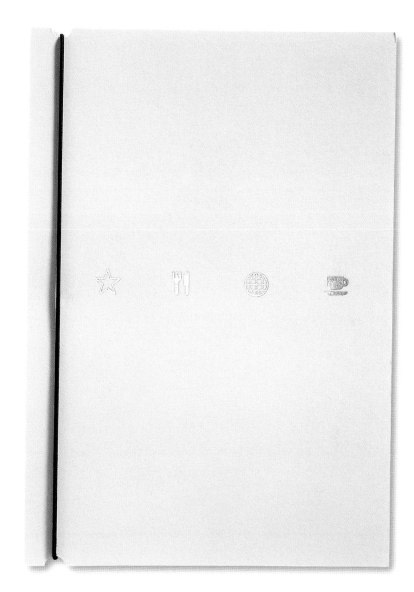

The London School of Business asked Lippa
Pearce Design Ltd. to design an invitation to a
traveling talk about the Euro. The design needed
an international/global sensibility because of the
nature of the topic and because it would be sent
to other countries. The designers worked to create
a "business class" feel: Silver, which is foil-
stamped onto the cover, works almost universally
as a sign of prosperity or money. The 4 $1/2$ x 6
$1/2$-inch (11 cm x 17 cm) invitation is bound by an
easily removable band that allowed the client to
customize the document for whatever country the
talk might travel to.

La Selva Cafe

Design firm
Formgivare Henrik Nygren

Designer
Henrik Nygren

Client
Mediebyran Agent

Paper
104 gr/m Mohawk Superfine Ultrawhite Eggshell
(letterhead); 270 gr/m small cards and arrow

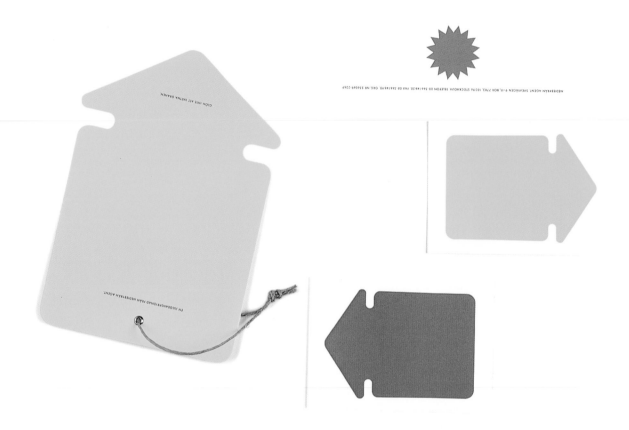

This system, which designer Henrik Nygren created for a media broker agent, is striking in its letterpressed simplicity. The designer has pulled to the fore two of the most common symbols found in print media, the sunburst and the arrow. Everyone would recognize these signs, he reasoned, no matter which language was being used. (This client is Swedish.) At the same time, they're strong, flexible graphic symbols that can be played with in many iterations. For instance, the card with the string tag is actually a holiday greeting meant to be hung on the recipient's Christmas tree. The downward-pointing arrow is meant to direct the viewer's gaze to the base of the tree and the message at the base of the card: "Do not forget to give the tree some water."

Utah Valley State College

Design firm
Meyer & Liechty

Creative director
Christopher Liechty

Designer
Sebastian Tatum

Photographer
Jon Rees

Writers
Christopher Liechty, Jennifer Kofford

Printer
Trade Engraving

Client
Utah Valley State College

Paper
110 lb. (cover) and 80 lb. (text) Classic Crest

Created by Meyer & Liechty for Utah Valley State College, the vision behind this design was to take the viewer by surprise. At first glance, the booklet's subtle color is evident. But when the reader picks it up, the incredible blind embossing reveals itself to the eye and the fingertips. The design firm worked with Trade Engraving in Salt Lake City, a printer with an enormous die press. The entire cover was struck in one hit, so the printer and designers had to work closely to keep registration tight and the pressure even. If too much pressure was applied, the paper broke. If too little pressure was applied, the type wasn't crisp enough, so finding a happy medium was a challenge.

Monderer Design

Design firm
Monderer Design

Designer
Jason C.K. Miller

Client
Self-promotion

Paper
70 lb. Astrolite vellum text (letterhead); 100 lb. Astrolite vellum cover (business cards); Starliner Blinding White uncoated (labels); Smart Paper, Carnival Punkin

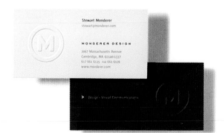

The paper stocks chosen for Monderer Design's stationery were picked to reflect the firm's studio space. Located in a converted brick-and-beam building in Cambridge, Massachusetts, the office's stark white walls and warm timber beams were translated by the designers into the company's stationery using Astrolite vellum and Carnival Punkin sheets. Monderer designers selected contrasting colors for the envelope and the letterhead, to provide a small surprise as the recipient opens the envelope. The stocks were also chosen for their ability to hold a crisp emboss.

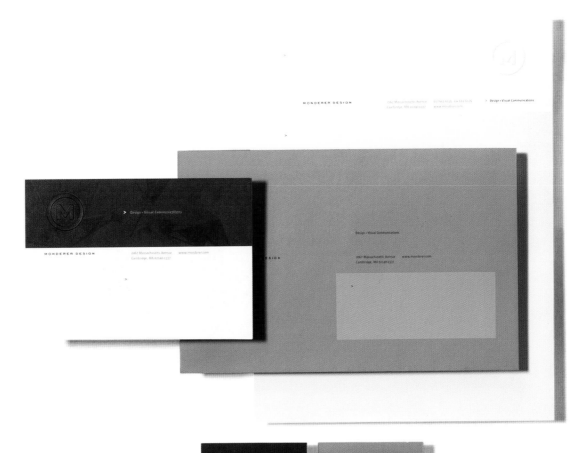

Heliotrope

Design firm
Werkhaus

Art director
Steve Barrett

Designer
Misha Zadeh

Production manager
Molly Costin

Client
Heliotrope

Paper
134 lb. Crane's Fluorescent White cover;
27 lb. Cromatica Azure (envelope)

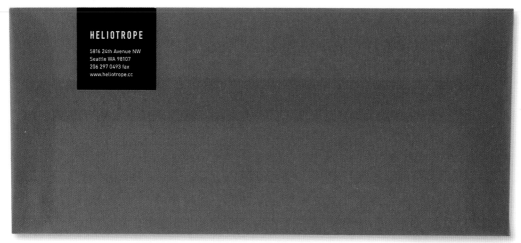

The three young architects who make up
Heliotrope specialize in simple, refined, elegant
work. They pride themselves on using clean
design and interesting materials. So a clean identity,
centered on a perfect square, was appropriate.
But rather than suggest an oddly shaped (square)
business card, designer Misha Zadeh proposed
perforating a standard-sized card at the 2 x 2-inch
(5 cm x 5 cm) point so that it could be folded over
to create its own architectural angle. Each partner
chooses a different color to use for personal
information and for envelopes.

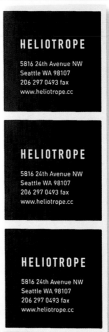

Chen Design Associates

Design firm

Chen Design Associates

Art director

Joshua C. Chen

Designer

Max Spector

Client

Self-promotion

Paper

Heavy blotter paper; Avery FasTrack High Gloss labels

Chen Design Associates created customizable holiday cards for its 2001 client mailing. The designers printed thermography on thick blotter paper to give the card a nice, toothy feel. Then, they color laser-printed three types of stickers— two with holiday-specific words, such as *joy, love,* and *kindness*, and one with words that capture the firm's design-specific philosophies or methodologies, such as *structure, movement,* and *contrast.* These stickers were randomly selected and applied to the cards in-house. This creates one-of-a-kind, four-color cards at a minimal cost.

Fellow Designers

Design firm
Fellow Designers

Client
Self-promotion

Paper
130 g. Scandia 2000 (letterhead); Brevpase
Scandia 2000 (envelopes); 115 g. Scandia
2000 (notepads)—all Svenskt Paper

RESPONS

RESPONS

RESPONS

Åsa Richter
Projektledare / Project Manager
Telefon +46-8-634 73 08
Mobil +46-70-577 28 33
Fax +46-8-634 73 60
asa.richter@respons.net
Respons AB
Gustavslundsvägen 141
Box 822 SE-161 24 Bromma
www.respons.net

Respons is a Swedish company that deals with
information directory inquiries. To symbolize
the nature of its business—handling phone
numbers, addresses, and so on—Fellow
Designers created for the client a logo that is
built entirely of holes. It's meant to symbolize
variable information and was inspired by old-
time data tapes. Production was a bit tricky.
First, the designers tried laser cutting, but it
left burn marks on the back side of the paper.
So they had a precise drill made, one that
could handle thicker paper and materials than
a laser could and still provide a feeling of
craftsmanship.

Charlie Palmer

Design firm
Hess Design Works

Creative and art director
Mark Hess

Client
Charlie Palmer

Paper
80 lb. Champion Carnival Groove

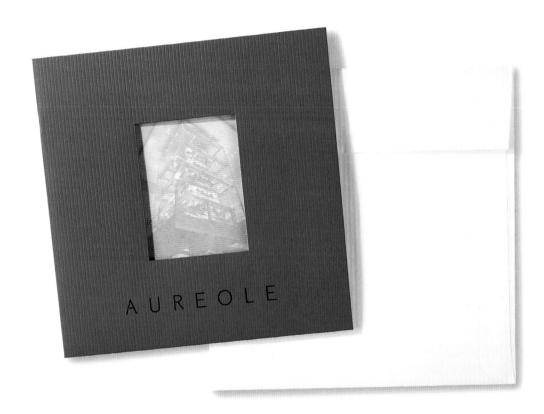

Top American chef Charlie Palmer's flagship restaurant in New York City, Aureole, has been top-rated in the Zagat survey for more than 10 years. In March 2000, Aureole Las Vegas opened in the Mandalay Bay Casino. Hess Design Works worked closely with Chef Palmer on this and other ventures. This sumptuous brochure is one of Mark Hess's creations. The same vertical-ribbed stock is used in the restaurants' menus, matches, press kit, and business cards. A photograph of the Las Vegas restaurant's impressive wine tower peeks out of a cutout through a layer of horizontally ribbed translucent stock.

GS Design

Design firm
GS Design

Art director, designer
Mike Magestro

Client
Self-promotion

One thing these visuals don't reveal to you is the almost rubbery nature of the screen-printing ink used on this oversized trio of invitations/posters. To increase the ink's opacity through heavier coverage on the vibrant papers and help it adhere to the paper better, a catalyst was added to the ink. The posters were hand-delivered to employees of Harley-Davidson—specifically, to the Harley Owners Group—to invite them to GS Design's annual bash. Paper colors were chosen for their "vibration" factor and to underline the party's 1970s theme.

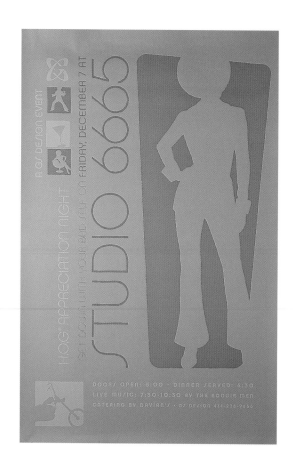

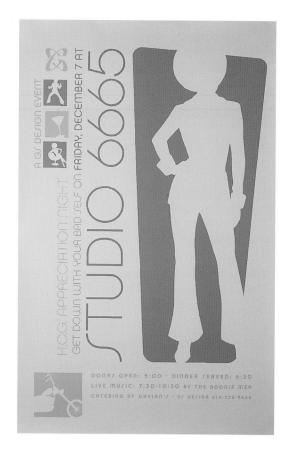

A GS DESIGN EVENT

H.O.G.® APPRECIATION NIGHT

GET DOWN WITH YOUR BAD SELF ON FRIDAY, DECEMBER 7 AT

STUDIO 6665

DOORS OPEN: 5:00 · DINNER SERVED: 6:30
LIVE MUSIC: 7:30-10:30 BY THE BOOGIE MEN
CATERING BY DAVIAN'S · GS DESIGN 414-228-9666

Point West London Ltd.

Design firm
Zulver & Co.

Design director
Andrew Zulver

Designer
Graham Birch

Illustrator
Leon Torka

Client
Point West London Ltd.

Paper
300 gsm Parilux Silk

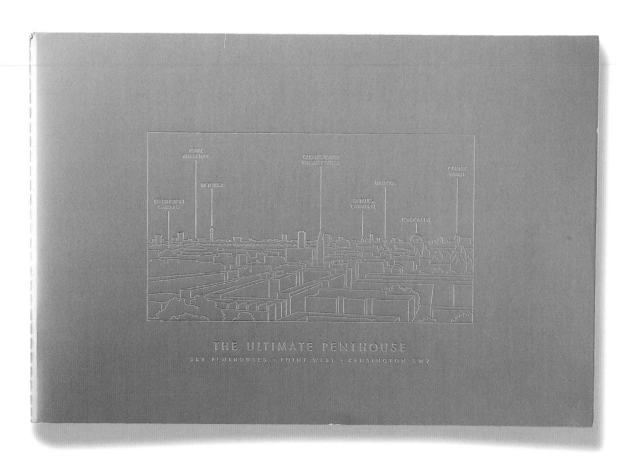

Point West London Ltd., a Singaporean/Regalian consortium, was selling The Ultimate Penthouse, a luxurious three-story penthouse occupying the 16th, 17th, and 18th floors of the Point West building in London's South Kensington for more than £6 million. Zulver and Co. was asked to create a marketing campaign for this prime property; the design firm's efforts eventually included this elegant book, bound by a uniquely debossed, silver paper cover. Meant to resemble the silver-engraved plaques that mark other views and landmarks in London, the deboss speaks of the stunning views the penthouse affords.

Art Director's Club

Design firm
Platinum Design

Creative director
Vickie Peslan

Designer
Kathleen Phelps

Text
Allison Curry

Client
Art Director's Club

Paper
Champion Benefit

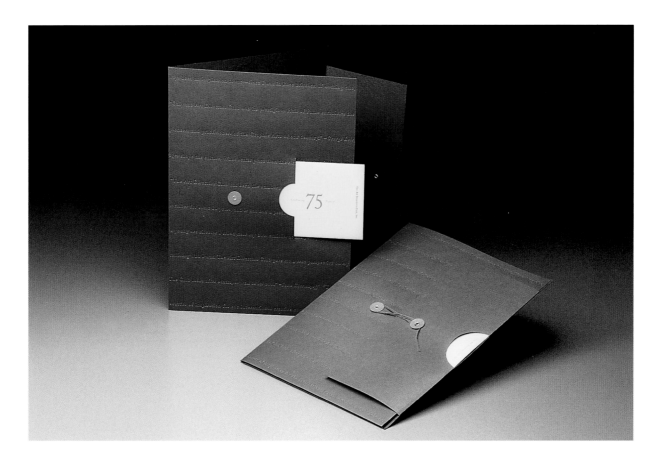

Designed by Platinum Design, this Art Director's Club media/capabilities kit was created especially for the group's 75th anniversary. Quotes from well-known international art directors are debossed on the cover. Moving the insert exposes the "75th Anniversary" message peeking through the window.

y wine

Design firm
Dossier Creative

Creative directors
Peter Woods, Don Chisolm (principal)

Client
y wine

Paper
Uncoated paper fitted to metal rim

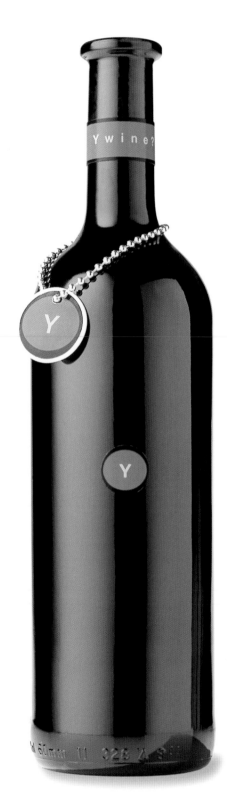

Wine can be intimidating, especially to younger drinkers with little experience in selecting and tasting the beverage. Y wine is a product created especially for them. These nonvarietal red and white table wines are meant to look cool and relaxed, not stuffy. Dossier Creative designers needed to create a look that would have immediate appeal to the target market, just like the wine's name. They devised a minimal design, a deliberate contrast to typically lush wine imagery that might include calligraphy, sophisticated color schemes, filigree borders, not stamping and illustrations depicting vineyards and ivy-clad chateaux. Small, colorful paper circles fitted to key foblike hangers offered just the right sense of modern spareness.

Unisource Canada

Design firm
Saldanha Inc.

Art director
Errol Saldanha

Client
Unisource Canada in association with Domtar Inc.

Paper
Domtar Sandpiper

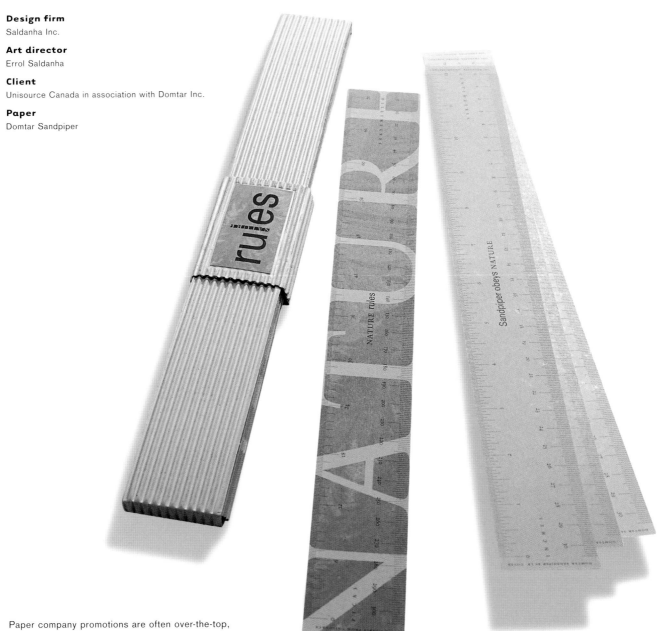

Paper company promotions are often over-the-top, and their audiences almost expect them to be that way. When Unisource Canada asked Saldanha Inc. to create a promotion that would show off its entire line of Domtar Sandpiper papers, it wanted something that was functional but that avoided the obvious choices, such as calendars, address books, paper pads, and so on. Errol Saldanha's solution was a stack of paper rulers in all colors and weights of the stock's range. Recipients were surprised by the long, thin package and actually used the rulers, which of course, makes the design memorable.

Beth Singer Design

Design firm
Beth Singer Design

Client
Self-promotion

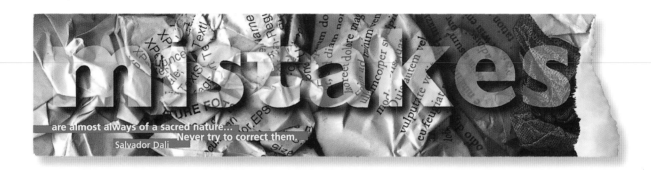

This simple bookmark was sent out with other
bookmarks to clients and associates as part of a
holiday gift from Beth Singer Design. The designer
was experimenting with a new Photoshop tech-
nique at the time. When the creative director saw
it, she intuitively ripped the end, and the solution
(which matched the quote) was born. Most people
"got" the visual pun, although some thought it
was a mistake. The client's son, age 11, handled
production and ripping.

The America's Cup

Design firm
Bull Rodger

Designer
Andrew Rodway

Copywriter
Paul Rodger

Photography
Allan Jones

Production
Calverts

Paper
Popset Oyster, 320 gsm

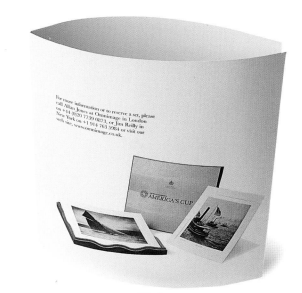

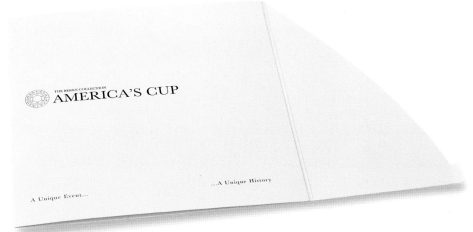

For a mailer advertising the sale of a
collection of limited-edition photographs taken from the 150-year history of
The America's Cup, the elegance and sweep of yacht racing came through
in a simple but emotional way. Bull Rodger solved the design problem by
creating a one-color, trifold brochure that folds out to reveal a diecut panel.
The natural curve of the paper echoes the shape of a wind-filled sail, a clear
appeal to any enthusiastic sailor.

Rawson Kehlman and Craig McLean

Design
Templin Brink Design

Client
Rawson Kehlman and Craig McLean

Paper
Various Crane cotton stocks

Craig McLean has a great reputation as a
quality winemaker, and Rawson Kehlman,
a vinter, owns a desirable plot of California
wine country land. When they joined forces,
an unusual move in the business, they needed
an identity that spoke of the heritage and
promise of both organizations'. Even though
the partnership was new, they wanted to look
as though it had been around for a long time.
Templin Brink developed stationery that had
that feel. The paper stock is printed to look
aged, and the signatures at the top of the
page definitely have flair. But then the designers
added a line of pin perfing on the stationery
that adds a tactile, more modern element.
"It isn't there to encourage people to rip the
paper," explains Joel Templin. "It's just a
very unusual look."

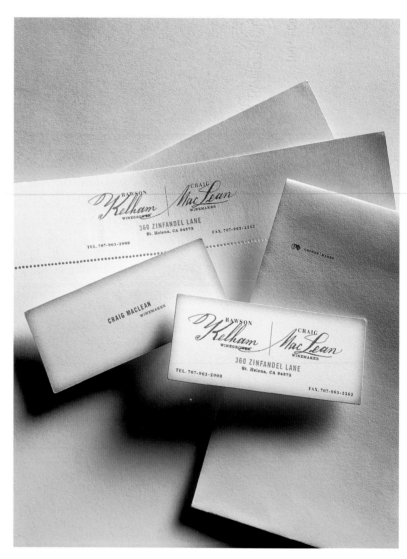

Pressley Jacobs Design Inc.

Design
Pressley Jacobs Design Inc.

Diecutting
Rohner Letterpress

Mailing label printing
Unique Printing

Insert card
Yorke Printe Shoppe

Paper
Kraft bags

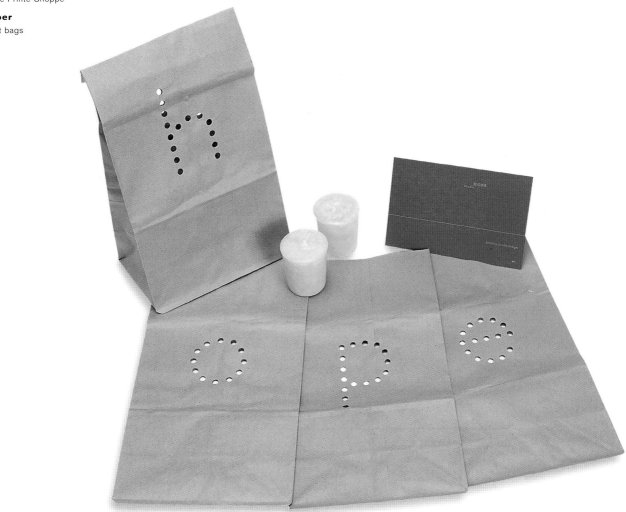

In 2001, Pressley Jacobs Design wanted to send out a holiday mailing that somehow addressed the tragedies of the past year, without falling back on patriotic themes. Instead PJD designers wanted to engender a sense of hope as a guiding light. So this luminaria set was both a quiet and appropriate medium for their message.

The "standard issue" bags were individually diecut on a letterpress. Placement and size of the letterforms were carefully considered to avoid diecutting the inside gussets. The designers tested several varieties of bag with candles inside to find the best luminosity and color.

Craig Dennis / Susan Eder

Pinecone

Design firm
Arts & Letters Inc.

Art director
Susan Eder

Designer/illustrator
Craig Dennis

Production
LaserExcel, Inc.

Paper
Appleton Currency 80 lb. cover

High Hopes

Design firm
Arts & Letters Inc.

Art director
Craig Dennis

Designer/illustrator
Susan Eder

Production
LaserExcel, Inc.

Paper
Hammermill BriteHue 65 lb. cover

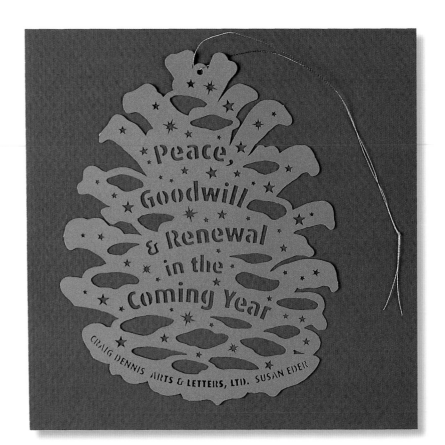

"Laser-cut paper always gets a reaction," says Susan Eder of Arts & Letters Inc., explaining why her firm has relied on the technique for its holiday mailers since 1986. "There isn't only the visual paradox of viewing an image through its negative [cut] presence but also the tactile involvement as well."

Ideas for the cards—provided to the printer as EPS files—are apt for the holidays but are really designed for an extended life. "We've learned that many clients keep the ornaments hanging near their desks all year, so we like for each to be as relevant in July as it was in December," Eder explains.

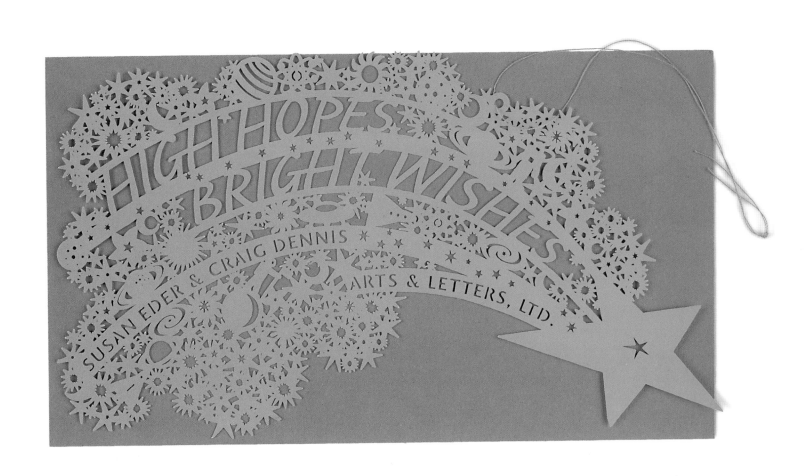

Carolyn Crowley

Designer
Carolyn Crowley

Client
Self-promotion

Paper
89 lb. Popset Plasma Blue Cover

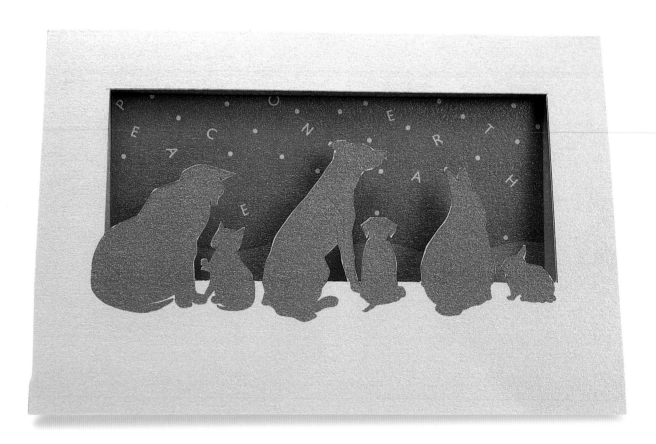

For her holiday card for friends and family in 2001, Carolyn Crowley created a hand-cut card based on a tender photo of her two cats looking out the window. The card was a hit, but some of her dog-lover friends got after her for being feline-centric.

"When thinking about this year's card, I thought that the message 'Peace on Earth' was really important. Featuring cats, dogs, and rabbits sitting quietly and peacefully together seemed appropriate—and it would make my friends happy," she says. The cards were printed out on a Epson color printer on silver-blue, slightly shimmery paper.

Getty Images

Design firm
Getty Images Creative Studio

Creative director
Chris Ashworth

Art director, designer
Michael Lindsay

Copywriter
Virginia Bunker

Client
Getty Images

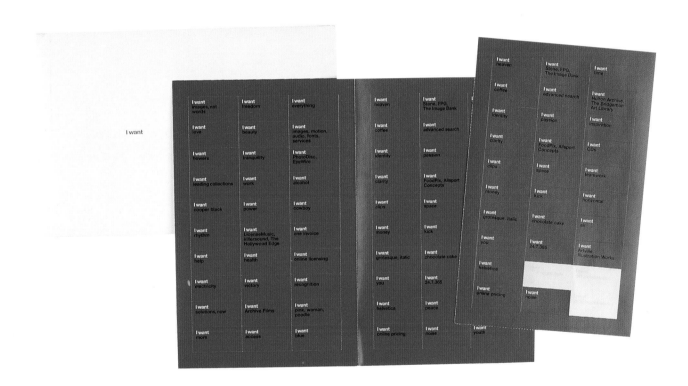

Designers at Getty Images wanted to create a direct mail piece with which recipients could have fun and interact. This, they felt, would create an emotional connection and, subsequently, a response. All stickers on the sheets represent universal wants. But they have multiple meanings and are keywords on the Getty Web site as well: Driving customers to the Web site was one of the main goals of the campaign. Art director Michael Lindsay reports that the fun element of the design continues to prevail: Customers call in to get additional sticker sheets so they can continue to build phrases in absurd combinations.

Blab

Illustrator
Michael Bartalos

Client
Blab

Paper
Bleached Mexican bark paper, imitation wood grain paper,
dyed Japanese paper, screen-printed Japanese paper, Canson
Mi-Teintes, Fabriano/Rives Laid, Pantone Black on Black

Artist Michael Bartalos says this is one of the
largest and most ambitious cut-paper illustrations
he has every produced. The diptych measures
35 x 18-inches (89 cm x 46 cm) and is made
entirely of cut paper: Even the text and punctuation
is hand-cut. Very sharp blades are required to cut
type this small—and about 50 blades were used.
A lightweight stock is also necessary for such fine
work. Bartalos affixes all pieces of his art onto
board using Sobo glue and plenty of patience:
This creation took 1 1/2 months to complete.

Applied Materials

Design firm
Gee + Chung Design

Creative director
Earl Gee

Designers
Earl Gee, Fani Chung

Photographer
Nick Veasey

Client
Applied Materials

Paper
150 lb. Utopia Premium Blue-White gloss cover

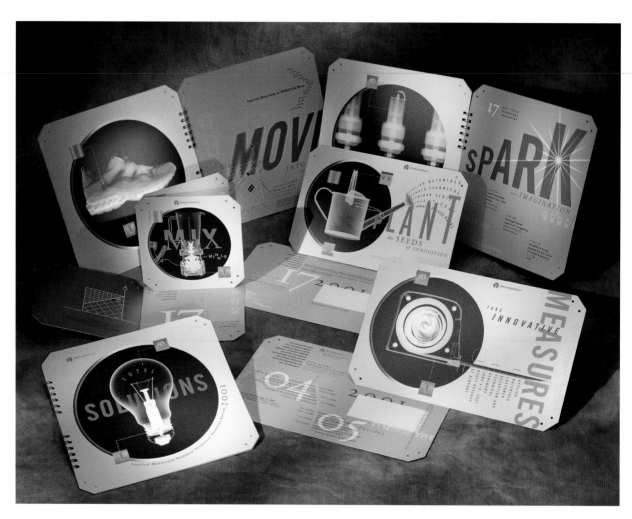

Applied Materials, a leading manufacturer of semiconductor fabrication equipment, needed a sequence of invitations for a series of seminars targeted toward silicon wafer engineers and fabrication specialists. Inspired by the shape of Applied Materials' silicon wafer fabrication chambers, designers at Gee + Chung Design decided to diecut the corners of the invitations and drill holes to simulate rivets. They selected a blue-white paper with a matte film lamination added on top to provide a smooth, silky, X-ray-like surface for the visuals and a polished, metallic finish for the wafer chamber background. The client reported that seminar attendance increased more than 150 percent, despite the down year for the semiconductor industry.

Blue Q

Art director
Scott Nash

Designer
Stefan Sagmeister

Client
Blue Q

Paper
Coated press sheets mounted to 100 pt. unlined board

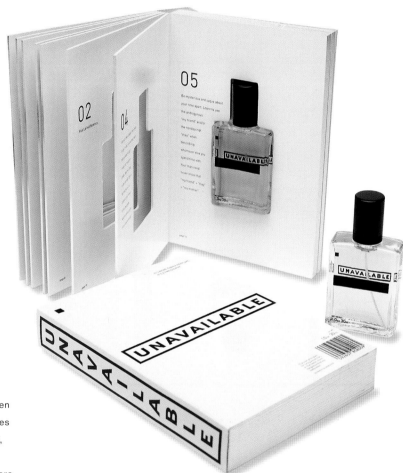

A perfume rarely has an "author," but that's the case for Unavailable and its concept-creator Karen Salmansohn. She noted that "a woman who makes herself unavailable (socially, emotionally, sexually, intellectually, geographically, or any combination thereof)" is suddenly irresistible to men everywhere. She approached Blue Q with her idea, and art director Scott Nash liked and subsequently presented a design brief to designer Stefan Sagmeister. The noted designer came back with a comp that is close to the final piece shown here. The proper way to become unavailable is outlined, page by diecut page, throughout the book. "We were lucky to have worked with just the right printer in Hong Kong," says Nash. "I believe they did one massive diecut through each book. Their finishing process was amazing."

Büro für Zukunftfragen

Design firm
Sigi Ramoser Designkommunikation

Art director
Sigi Ramoser

Designers
Sigi Ramoser, Klaus Österle

Client
Büro für Zukunftfragen

Paper
Various uncoated card stocks

Sigi Ramoser designed these postcards so that each would carry a sentence about how we are or should be spending our time optimally. Also on every card is a small hole to look through toward the future. Produced for what translates roughly to the Office for Questions of Our Future (a department of the Austrian government), the cards are designed entirely to make people pause and reflect.

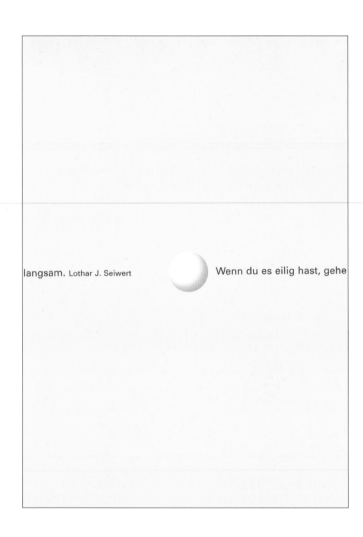

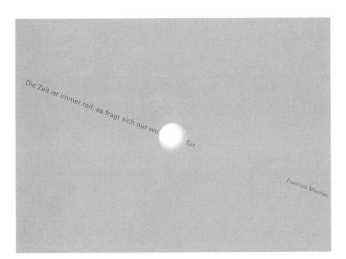

Die Zeit ist immer reif, es fragt sich nur wofür.

Francois Mauriac

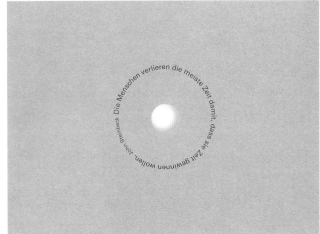

Die Menschen verlieren die meiste Zeit damit, dass sie Zeit gewinnen wollen. John Steinbeck

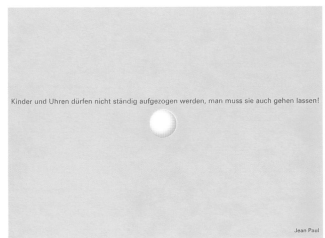

Kinder und Uhren dürfen nicht ständig aufgezogen werden, man muss sie auch gehen lassen!

Jean Paul

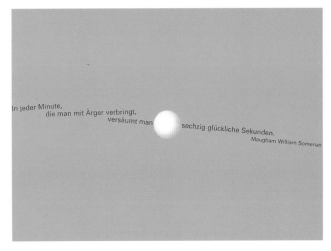

In jeder Minute,
die man mit Ärger verbringt,
versäumt man sechzig glückliche Sekunden.

Maugham William Somerset

Kitchen K

Design firm
KINETIK Communication Graphics

Designers
Jeff Fabian, Sam Shelton, Mila Arrisueno,
Beth Clawson, Richard Fischer, Monica Gornikiewicz,
Beverley Hunter, Ali Kooistra, Katie Kroener, Stephen Oster,
Natalie Politis, Jackie Ratsch, Scott Rier, Kamomi Solidum,
Jason Thompson, Matt Wahl

Printers
C&R Printing (letterhead); Beach Brothers Printing (cards)

Paper
Mohawk Navajo text and cover

Kitchen K is a graphic design exhibition space in
Washington, D.C. Of course, its identity needed
to be strong and memorable, like the work that
would be shown within its walls. Founders Jeff
Fabian and Sam Shelton, already aficionados of
typography, became intrigued with the idea of
using a single letter as a business card after
spying a chair made entirely out of the letter A in
Amsterdam. So commenced an amazing amount of
research on the letter K. The duo eventually pulled
together a three-ring notebook with about 250
different letter K's in it before they picked their
favorites. The diecut cards are handed out at
random. Some recipients are even trying to collect
the entire set.

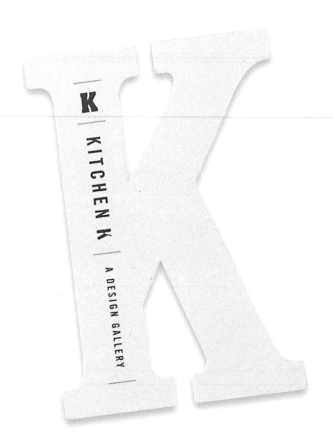

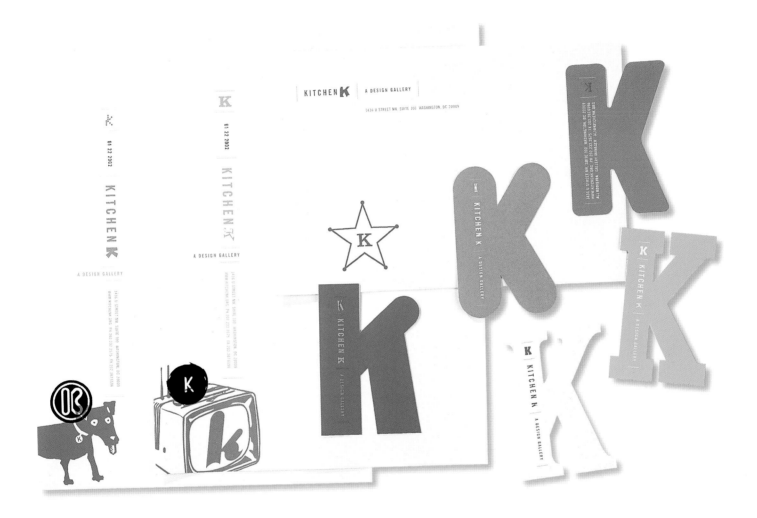

Pressley Jacobs

Design firm
Pressley Jacobs: a design partnership

Art director
Amy W. McCarter

Designer
Jef Anderson

Client
Self-promotion

Paper
110 lb. Starwhite Sirius cover

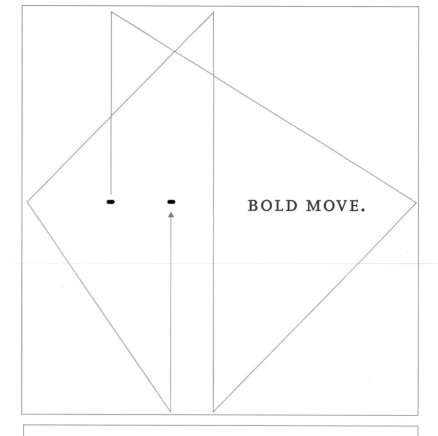

Pressley Jacobs' recent moving announcement has a dual message: The firm made a physical move to a new office, but it also made a "move" in the way it's structured. (The office is now a partnership with three principals.) The letterpressed words *Bold Move* speak of both the physical and structural expansion of the office. The payoff is on the second side: "Short distance" defines how close the new space is to the old space—and it also confirms that the PJ designers are still the same down-to-earth people.

BOLD MOVE.

SHORT DISTANCE.

One North Wacker Drive
Suite 950
Chicago, Illinois 60606
T 312·263·7485 F 312·263·5419

PRESSLEY JACOBS A DESIGN PARTNERSHIP

We are pleased to announce our
relocation, just a few doors down.

Please update your records.
Effective January 28, 2002.

SP Masonry

Design firm
Tower of Babel

Designer
Eric Stevens

Client
SP Masonry

Paper
Fox River Confetti in Rust

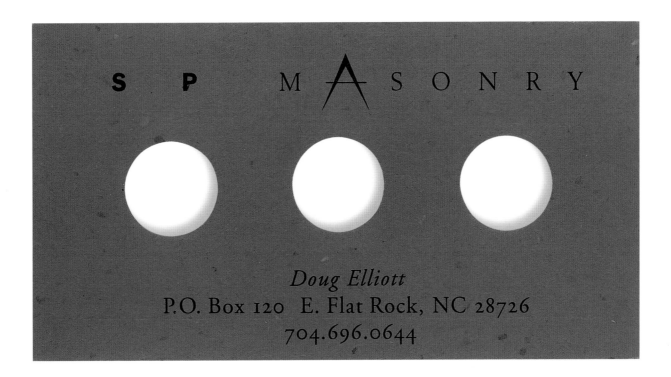

Designer Eric Stevens calls his clever "brick card," which he created for a local mason, "dumb luck." The cards are drilled to keep costs down, and Stevens was fortunately able to find the perfect paper stock for the job: rust in color and with a slight speckle that simulates the variation of texture found in bricks. Even though the client and the designer were satisfied with the design (Stevens says he wishes they had the funds to see through a companion "cinder-block letterhead" concept) and the design is an Addy-award winner, he ended up taking the piece out of his portfolio: When he moved to the West Coast from North Carolina, no one recognized the shape. Apparently, bricks with three holes are endemic to the Southeast, not the Northwest.

no.parking

Design firm
no.parking

Designer
Sabine Lercher

Client
Self-promotion

Paper
250 g Sappi Magnomat Satin

This greeting card carries on the design firm no.parking's tradition of creating multifunctional mailings—that is, mailings that have additional uses after their initial task is completed. In this case, the New Year's card first conveys the season's warm wishes to the recipient. Then that person can tear off the perforated Pantone scale rectangles on the left side of the card. On the back of each square is the company's contact information, so each piece functions as a little business card.

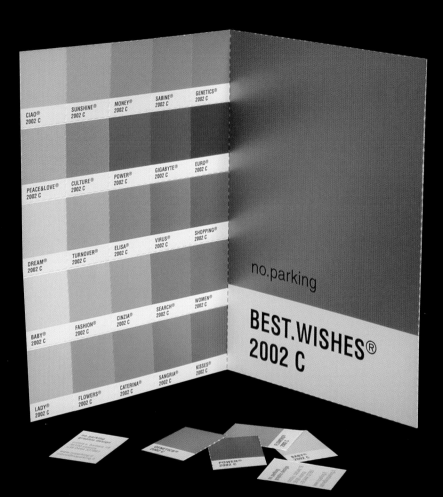

Century Resources

Design firm
Salvato, Coe + Gabor

Client
Century Resources

Paper
0.018 Bending Chip

Gladiolus box
Art director, designer: Mark Gormley
Photographer: Tom Hogan

Tulip box
Art director, designer: Mark Gormley
Photographer: Peter Coe

Anemone box
Art director, designer: Steve Gabor
Photographer: Tom Hogan

Buttercup box
Art director, designer: Sean Malloy
Photographer: Tom Hogan

Small bulb box
Art director, designer: Andy Kuick
Photographer: Tom Hogan

Medium bulb box
Art director, designer: Andy Kuick
Photographer: Tom Hogan

Large bulb box
Art director: Andy Kuick
Photographer: Tom Hogan

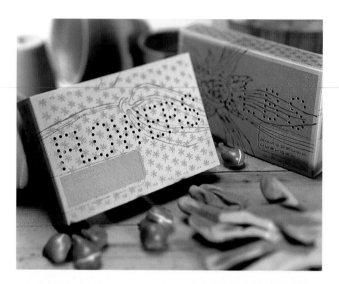

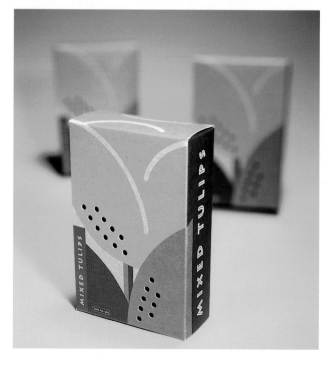

Century Resources is a leading provider of
school and youth-related fund-raising programs.
One of its for-sale offerings is flower bulbs. The
company wants buyers of its products to feel
as though they've received something of real
value, and one of the components of that value
is presentation. Century management charged
Salvato, Coe + Gabor with developing packaging
that would accomplish this. Kraft paper, graphic
artwork, and a soft palette of three inks per box
spoke well of what was inside the boxes. But
another design element actually took care of the
contents: Each box has a unique configuration
of holes, which allow air to circulate among the
live bulbs. But the holes are also placed carefully
to enhance the natural patterns and flow of the
boxes' designs.

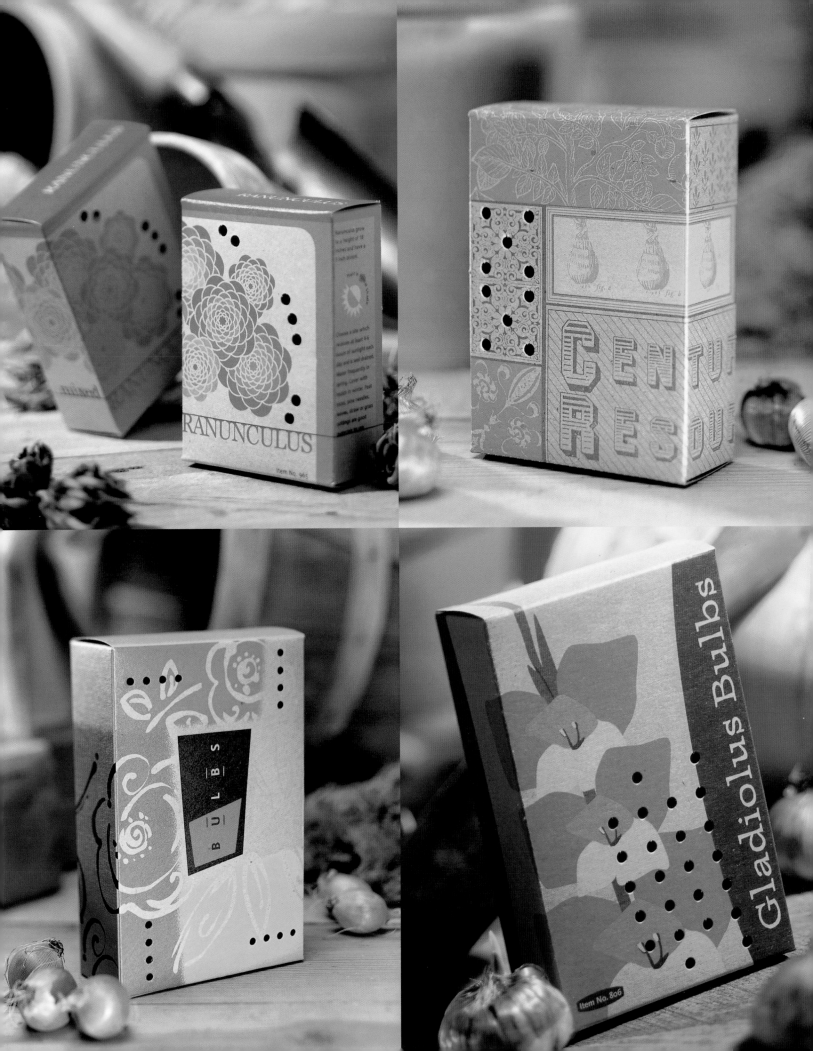

Nature's Palette

Design firm
DotZero Design

Designers
Jon Wippich, Karen Wippich

Client
Nature's Palette

Paper
80 lb. Neenah Classic Crest

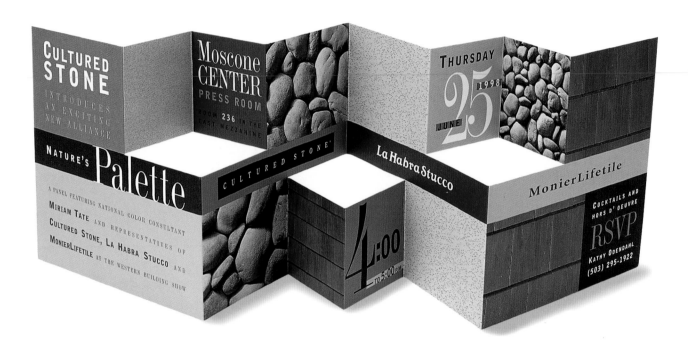

An invitation to a panel discussion at a builder's trade show, this three-dimensional, accordion-folded design was created to instantly grab the recipient's attention as soon as the envelope was opened. The event was sponsored by three manufacturers who had gotten together to coordinate the colors of their shingles, cast stone and stucco, and the piece had to represent all three products. DotZero Design's creation has strength and structure, despite the fact that its construction is simple—just three diecuts and 12 fold strikes.

Monster Design

Design firm
Monster Design

Client
Self-promotion

Paper
130 lb. Mohawk Superfine cover

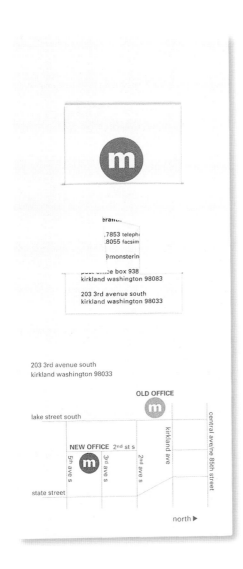

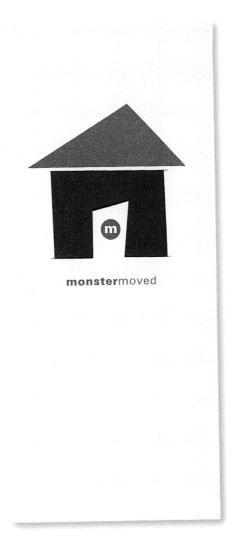

Creatives at Monster Design like to keep things simple. When they were looking for an interesting way to include their new business cards in the company's moving announcement, they came up with a simple, yet elegant solution: Tuck the card into the space left by a building-shaped diecut. (The firm had moved from a loft space into a house right in the city.)

Archebit-Digital Excellence

Design firm
no.parking

Designer
Elisa Dall'Angelo

Client
Archebit-Digital Excellence

Paper
(Clover cover) 300 g/mq Invercote Creato Matte,
plasticized (Clover inside) 115 g/mq coated matte;
(Archebit cover) 300 g/mq Invercote Creato Matte,
plasticized; (Archebit inside) 240 g/mq Arjo Wiggins
Popset Cyrogen white

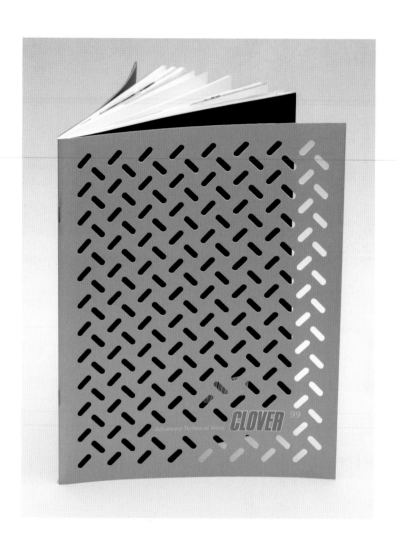

These two intriguing samples of diecutting from
no.parking both use a plasticized paper to provide
strength for the extensive trauma done to the
covers. The first diecut, designed for Clover,
which manufacture advanced technical wear for
motorcyclists, mimics cycle tracks. The second,
created for Archebit-Digital Excellence, an Internet
services company, is more about aesthetics: It
allows the strong orange inside the brochure to
show through. The round shape reproduces the
company's logo. Cards found inside this brochure
are also diecut: The holes indicate the number of
the page and help with proper sequencing.

in prima fila nell'evoluzione digitale

la società

archebit

osofia

istemi

Talkopia

Design firm
Helen Sun Design

Creative director, designer
Helen Sun

Art director
Scott Wallin

Client
Talkopia

Paper
80 lb. Starwhite Vicksburg text and cover

Talkopia is a communication tool that is focused on bringing free, PC-to-long-distance phone service to global Internet users. Designers Helen Sun and Scott Wallin knew this was definitely a product aimed at the Generation Y consumer. After experimenting with a design that incorporated an abstract cityscape—representative of Talkopia as a new lifestyle for worldwide users—the pair created a design that mimicked the computer screen itself. Bold colors and playful diecuts on the shipping label and business card create a sense of familiarity and ease of use. The logo itself contains a cartoon talk bubble, which is another fun touch.

talk o pia

11150 santa monica boulevard, suite 650
los angeles, california 90025

www.talkopia.com

talk o pia

11150 santa monica boulevard, suite 650
los angeles, california 90025

B T T N »

www.talkopia.com

310.478.5555

www.talkopia.com

310.478.5550

Turquoise Creative

Design firm
Turquoise Creative

Art director, designer, illustrator
Misha Zadeh

Client
Self-promotion

Paper
80 lb. Classic Crest Solar White cover; 27 lb.
Cromatica Vermilion, Absinthe and Azure; 30 lb. Reich
Paper Chartham Translucents Earth Brown and Blush;
80 lb. Curious Metallics Galvanized text

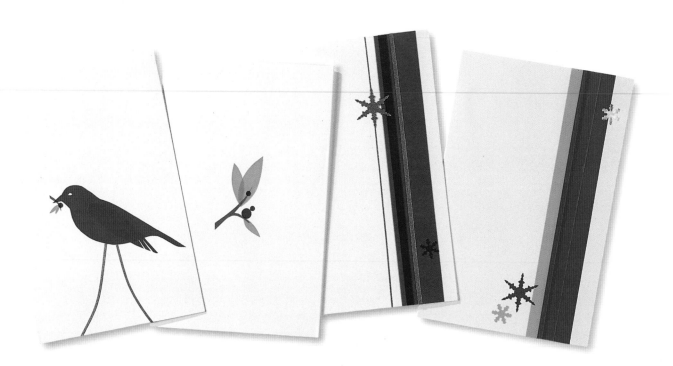

Designer Misha Zadeh of Turquoise Creative
undertook a challenging project during her first
year in her own studio: She crafted quartets of
handmade cards as client gifts, each featuring
her cut-paper illustration style and using the most
interesting papers she could find. The theme of
translucence and layering is carried out in the
glassine envelope and clear labels she specified.

Alternative Paper

CHAPTER 5

AT BOTH ENDS

FREELANCE CREATIVE TEAM

ART
JUDITH TACELLI
63 TROWBRIDGE STREET
ARLINGTON, MA 02474
JUDITH@ATBOTHENDS.COM

617 686 1843

COPY
KEITH BUFFO
27 MIDDLESEX ROAD
STONEHAM, MA 02180
KEITH@ATBOTHENDS.COM

781 435 1455

At one time, alternate papers—defined for the pur-
poses of this book as paper made from something
other than wood fiber—were unusual and expensive.
Today, however, as alternate paper manufacturers
have perfected their manufacturing processes and
have much more competition, prices for papers
made from seeds, coffee, beer labels, plants, hops,
junk mail, plastics, and even seaweed have dropped,
although their interest factors remain high.

Added to the alternate paper palette is the use of
paper products that were never intended to be
included in a graphic design, such as cocktail nap-
kins and rolls of tickets. Even good, old, chunky
construction paper is making a comeback, as shown
by the stationery here.

ART
JUDITH TACELLI
63 TROWBRIDGE STREET
ARLINGTON, MA 02474

617 686 1843
JUDITH@ATBOTHENDS.COM

COPY
KEITH BUFFO
27 MIDDLESEX ROAD
STONEHAM, MA 02180

781 435 1455
KEITH@ATBOTHENDS.COM

GS Design

Design firm
GS Design

Art director, designer
Mike Magestro

Hand-lettering
Dave Kotlan

Client
Self-promotion

Paper
Napkins

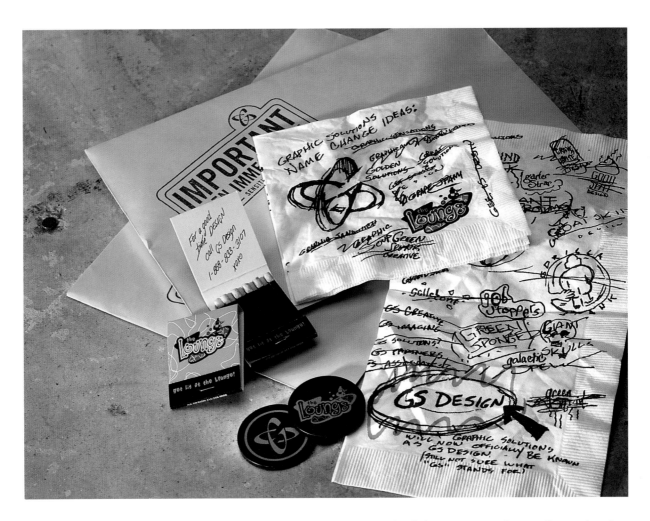

When Graphic Solutions, Inc., changed its name to GS Design, its creatives wanted to find a way to communicate to clients and vendors the brainstorming process they went through to reach the new moniker. Their solution was to print actual napkins that looked as if the team had been sitting around in a bar, throwing out ideas, scribbling them down, and had finally come up with just the right name. Although the black ink on the napkins is letterpress printed, the red ink was added with an actual pen for a more realistic look. After a quick crumple, the napkins were stuffed into envelopes together with a few poker chips and a book of lounge matches.

Continental Corporate Engravers

Design firm
Spielman Design

Designer
Amanda Bedard

Copywriter
Sarah DeFilippis

Agency
Dialogic

Paper
Chromatica, mango (envelope); Rives BFK (card);
Koshiji (insert)

The mango orange envelope with red type
really makes this holiday card stand out in the
crush of the season's mail. Amanda Bedard of
Spielman Design created the ensemble for
client Continental Corporate Engravers.
Bedard selected a red and gold Japanese
paper for the insert for its festive and compli-
mentary feel as it lay inside of the envelope
and card.

To add dimension, an inkless die was used to
strike the envelope paper. "Embossing the
star provided a nice balance of interior and
exterior design components," she says about
the design, which was sent out to remind
graphic designers about the approaching holi-
day season and the need to get busy on their
own and their client's cards.

Elvis and Bonaparte

Design firm
Elvis & Bonaparte

Creative director
Dave Helfrey

Art directors
Karen Wippich, Jon Wippich, Marie Murphy

Designers
Karen Wippich, Jon Wippich

Illustrators
Dave Helfrey, Karen Wippich, Jon Wippich

Writer
Stacy Bolt

Client
Self-promotion

Paper
Inkjet paper

Elvis and Bonaparte, an ad agency, was throwing a big Halloween party for employees, clients, and friends. What better form than matchbooks for an invitation to a party with the theme of the nine levels of hell? The agency's designers used existing matchbooks to produce about 400 invitations: First, they stripped the covers off of the books and replaced them with new covers, printed in-house. The striker strip—already scarred for an extra touch of reality—was scanned and added as part of the new covers. Three different designs were produced, each with different graphics and the message, "Go to hell!"—appropriate for a party held at a club called Dante's.

R.E.M.

Design
Bruce Licher

Printer
Independent Project Press

Client
R.E.M.

Paper
Chipboard

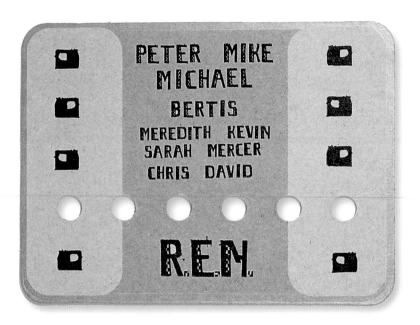

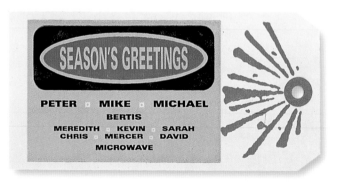

Bruce Licher and Independent Project Press have been producing a holiday greeting card for a fan club package for the group R.E.M. for about 10 years; shown here are two recent examples. The tag/card idea was art-directed by R.E.M.'s in-house designer. He asked for an "industrial warning" look, which was the direction in which the package was moving. So Licher scouted through industrial supply catalogs until he ran across the tags, which his client loved. However, the tags were a bit of a challenge to letterpress print on: Printing had to reach nearly to the edges of the tag, and there was the pre-existing reinforced hole to work around. But in the end, Licher was able to complete a run of about 7,000 cards.

Bloomberg Personal Finance Magazine

Illustrator
Michael Bartalos

Client
Bloomberg Personal Finance magazine

Paper
French Paper Frostone, Japanese screen-printed
papers, Canson Mi-Teintes, various scrap

Artist Michael Bartalos travels the world in
search of inspiration and specialty papers for his
cut-paper illustrations. The best sources, he
says, are art stores in Tokyo, but he also saves
the wrapping paper that Japanese stores use to
swaddle merchandise for customers. Some of
these papers are found in this 10 x 13-inch (26
cm x 33 cm) illustration for *Bloomberg Personal
Finance* magazine. In creating a detailed piece
of art like this, Bartalos says, "The less planning,
the better."

"Each artwork's direction is dictated by availability
and performance of material; these limitations
often improve on my original plans," he says.
"Letting go of expectations and allowing the
paper to do the work results in the best pieces."

Carolyn Crowley

Designer
Carolyn Crowley

Client
Self-promotion

Paper
Worldwin Extraordinary Papers, white vellum cover stock

For her new self-promotion, Carolyn Crowley wanted to create something that would be elegant and simple, neutral and earthy, self-contained and too precious to throw away. Her solution was a cleverly folded vellum shell, an idea that grew from a Japanese envelope design she had spotted in a gift-wrapping book. "It reminded me of my logo in which similar shapes interlock to form one shape," she says. "If I made it out of vellum, these shapes would be more visible, and I could experiment with overlapping colors."

The 4 x 4-inch (10 cm x 10 cm) envelope shape is made out of four overlapping circles, created in Illustrator. Then Crowley printed the design onto vellum, trimmed the design out, folded it, and tucked work samples inside.

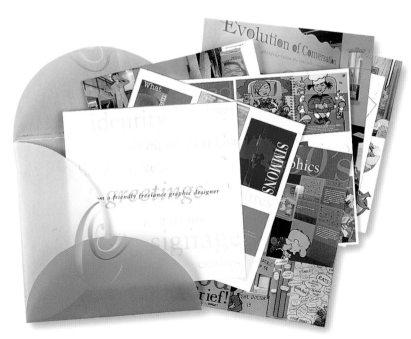

At Both Ends

Design firm
At Both Ends

Designer
Judith Tacelli

Client
Self-promotion

Paper
Riverside Paper construction paper

Because At Both Ends' logo has a rough-hewn, cutout quality, firm designer Judith Tacelli felt that good old construction paper—exactly the kind used in grade schools everywhere— would be the ideal stock for her company's stationery. The yellow and orange tones of the logo's burning candle is a perfect tonal match to the muted shade of the manila sheet she selected. The business cards are mounted on a second piece of orange construction paper for extra body and color. An added bonus to using the stock: The Epson Stylus Photo 1200 printer she uses to produce the stationery prints beautifully on the stock.

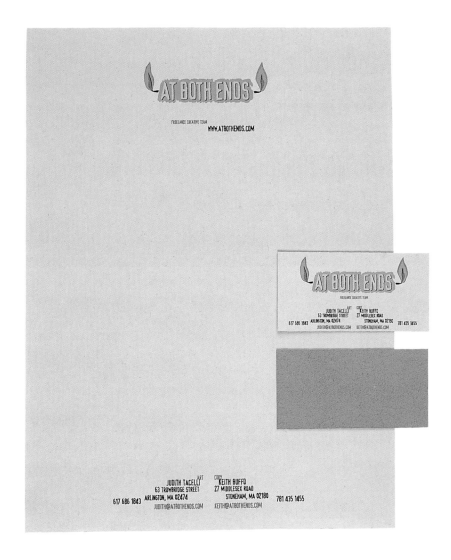

WORK BY BOB DAHLQUIST

Design
Bob Dahlquist, Bob's Haus

Paper
Diazo paper and Mylar

Bob Dahlquist happened upon diazo paper while he was doing some personal work and was drawn to the large-format, old-fashioned medium. "It probably won't be around much longer," the artist says. He liked the materials themselves: contrasting warm and cool tones, plus subtle and deep shading. He produces the pieces on a big blueprint machine, sometimes laying objects directly on light-sensitive blue-tone, brown-tone, or sepia-tone translucent Mylar. Exposing the compositions to different kinds of light produces different effects: Fluorescent light creates a softer edge, while halogen light or sunlight creates a harder definition.

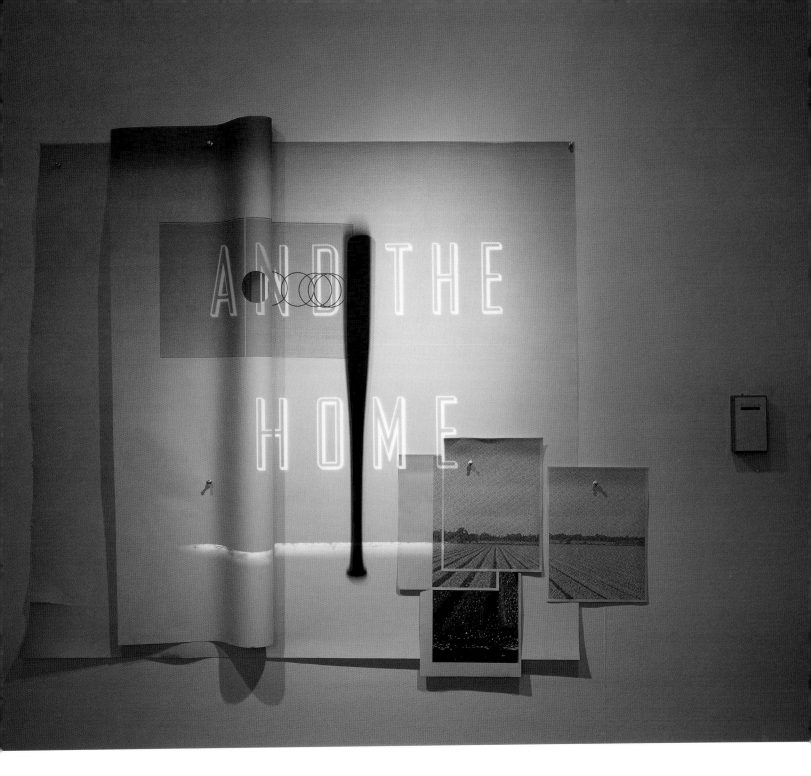

Heroes II, (at left) he says, is about the conflict inherent
in being mortal and human; there are always bigger
shoes to fill. Sactoflag6 (above) was created for a book
commemorating Sacramento's new baseball team,
ballpark, and the team's inaugural season.

Singer/Smith Families

Design firm
Beth Singer Design

Client
Singer/Smith Families

Paper
Handmade paper

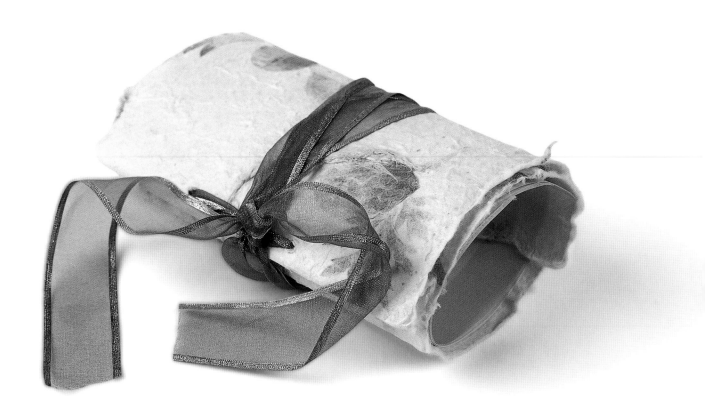

Designer Beth Singer used this pretty, flower petal–embedded, handmade paper for her own wedding program. For the spring ceremony, she liked the idea of flowers pressed into a lacelike texture; the addition of a semitransparent ribbon completed the package. Her advice to others specifying such handmade paper? "It's expensive," she says, "so try to get as many pieces out of one sheet as possible."

Greenfield Paper Company

Design firm
Mires Design

Creative director
Jose Serrano

Designer
Michael Perez

Illustrator
Tracy Sabin

Client
Greenfield Paper Company

Paper
Various hand-crafted sheets

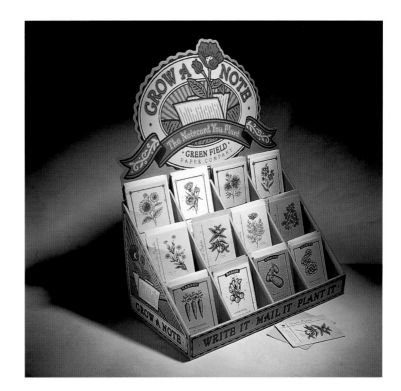

Everything Mires Design created for the Grow A
Note line of products supports the novel product's
core premise: You can plant the card. The paper
itself is actually the product, containing seeds for
vegetables, herbs, and flowers. This means it must
be handled a bit differently than conventional
paper. The embedded seeds create a bumpy
surface on the paper, so the designers resorted
to letterpress printing rather than conventional
offset, which would have smashed the seeds as
the paper passed through the press's rollers. In
addition, the cards are produced using soy inks
and recycled materials, so they're 100 percent
environmentally sound.

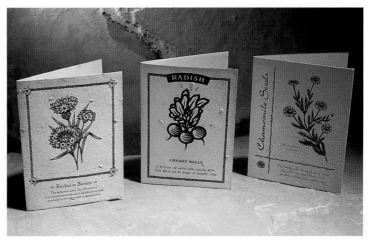

Group Baronet

Design firm
Group Baronet

Creative directors
Willie Baronet, Meta Newhouse

Designer
Bronson Ma

Illustrator
Willie Baronet

Client
Self-promotion

Paper
80 lb. Curious Metallics Anodized text

What can look like a simple job can actually be
the end of a long, circuitous route, as most
designers know. This simple but elegant holiday
greeting from Group Baronet was such a case.
Principal Willie Baronet says, "Millions of snow-
men were drawn in various illustrative styles using
different media." But a naïve style seemed to fit
the group's message best: "If we had no winter,
the spring would not be so pleasant. If we did not
sometimes taste of eternity, prosperity would not
be so welcome." Silver paper printed with a
double bump of white ink, and a single pass of
black kept the effect very clear.

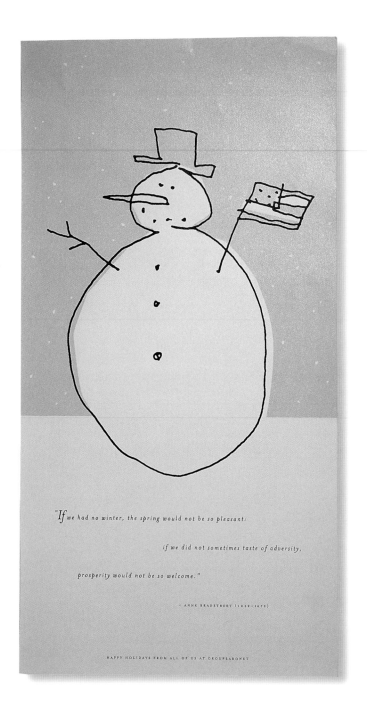

"*If* we had no winter, the spring would not be so pleasant:

if we did not sometimes taste of adversity,

prosperity would not be so welcome."

– ANNE BRADSTREET (1612–1672)

HAPPY HOLIDAYS FROM ALL OF US AT GROUPBARONET

Splash Interactive

Design firm
Splash Interactive

Creative director, art director, designer
Ivy Wong

Client
Self-promotion

Paper
Curious Paper in White and Lustre

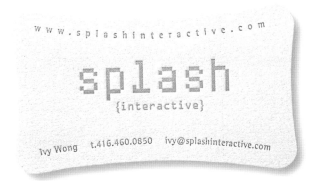

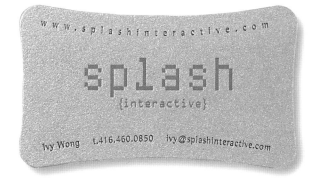

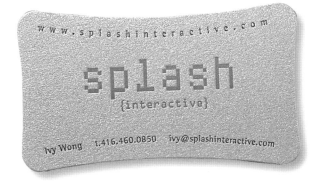

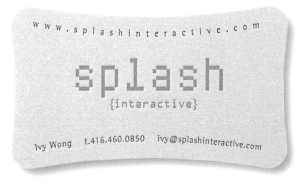

When you make a splash, it usually involves liquid, points out Ivy Wong of
Splash Interactive. And liquid is never square: Instead, it's smooth and curvy.
Trying to stay within normal business card parameters, Wong developed this
undulating shape. But to focus the reader on the printed information, she kept
the card symmetrical. The cards come in two colors, each with a different
thickness or weight. Wong likes giving recipients a choice of card: dark or
light, thick or thin.

Via Motif

Design firm
Vrontikis Design Office

Art director
Petrula Vrontikis

Client
Via Motif

Paper
Curious Metallic

Petrula Vrontikis of Vrontikis Design Office loves unique papers—so much
so that her paper reps keep an eye peeled for paper that might interest her.
Such was the case with this slightly goldish green, faintly shimmering sheet
that covered a promotion for Via Motif, a style and lifestyle retail boutique.
The principal's designers had just created a new identity for the retailer, and
the green of this paper matched the new, green identity color. This special
paper also matched the client's creative and sophisticated tastes perfectly.

Caroline Schlyter

Design firm
Formgivare Henrik Nygren

Designer
Henrik Nygren

Client
Caroline Schlyter, furniture designer

Paper
Birch paper pulp

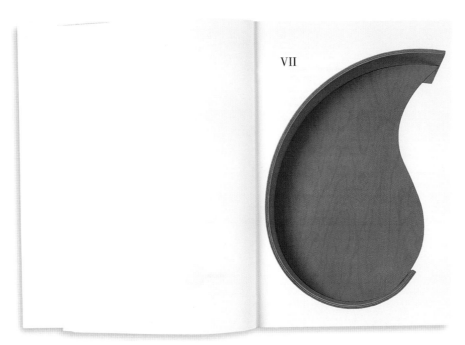

Caroline Schlyter is an industrial designer who creates furniture from birch.
When graphic designer Henrik Nygen was asked to create a catalog/promotional
piece for her business, he knew he could rely on the same material. He speci-
fied paper pulp made from birch. "It looked and felt good, almost like wood," he
says, "and it's certainly as tactile as her furniture." What if no one but he and
his client recognizes the significance of the paper? Nygren says that doesn't
concern him. It's still beautiful, and even with nothing printed on it, it felt
especially good to him.

Alan Di Perna, Chickenscratch, and Independent Project Press

Design
Chickenscratch—Summation, Cave Creek,
Ariz.; Di Perna card and IPP moving
announcement—Bruce Licher

Printer
Independent Project Press

Client
Alan Di Perna, Chickenscratch, and
Independent Project Press

Paper
Chipboard

Bruce Licher has become well-known in design circles for his magical use of what might otherwise be regarded as a very base print substrate: chipboard. Using hand-letterpress printing, he uses clay-coated and uncoated chipboard of various weights to physically punch his designs onto the board. "Chipboard isn't made to be consistent," he says. "It often comes from floor scraps from the paper mills, [so] you never know what you'll get until the bundles arrive." This unpredictability can actually be a design advantage: For instance, for the Alan Di Perna cards, Licher printed on several different weights of board. Di Perna now has thick cards to hand out when he really wants to make an impression and thinner versions to just have available in his wallet.

Design Asylum

Design firm
Design Asylum

Art director
Christopher Lee

Designers
Christopher Lee, Cara Ang, Kai, Larry Peh

Copywriter
Evelyn Tan

Photographers
Christopher Lee, Kai, Larry Peh

Illustrators
Christopher Lee, Liew Weiping, Cara Ang, Michelle Tan

Client
Self-promotion

Paper
65 gsm Newsprint

To celebrate its first year in business, Design Asylum held an exhibition in an art museum and wanted to create a brochure that would announce and be an extension of the event. But the firm's designers didn't want a typical document. Instead, they went large, creating a tabloid-size brochure, even opting to print it on newsprint, like a newspaper. The nature of the paper and the size of the document provide a much more interesting feel as well as immediate impact. The newsprint conveys the message that art isn't for the elite, but for the masses, notes art director Christopher Lee.

ONE.

CALL US SENTIMENTAL FOOLS, BUT WE THINK TURNING ONE CALLS FOR A CELEBRATION. AN EXHIBITION THAT'S REVOLVED AROUND WHAT ELSE BUT, ONE. AND SINCE WE'RE IN THE BUSINESS OF COMMUNICATION, EACH OF US HAS CREATED AN INSTALLATION PIECE REFLECTING OUR OWN PERCEPTION OF THE NUMBER. CRITICISMS OR ACCOLADES, IT'S OUR TRIBUTE TO LOOKING AT LIFE FROM DIFFERENT PERSPECTIVES. AFTER ALL, WE ARE ASYLUM.

Discover the beauty in the insignificant. For it is with the seemingly insignificant that a greater entity is formed. It is the parts that form the whole. Each part serving a specific function. Enabling the whole to work as ONE.

Paul Smith

Design firm
Aboud-Sodano

Art director
Alan Aboud

Designer
Mark Thomson

Photography
Ellen Nolan

Client
Paul Smith

Paper
Continuous-form waybills

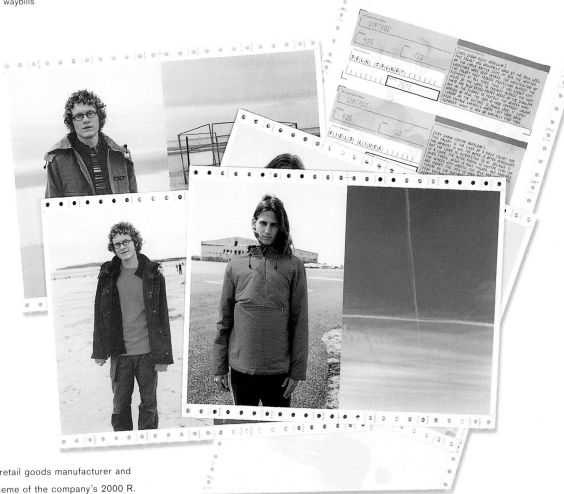

Paul Smith is a retail goods manufacturer and
designer. The theme of the company's 2000 R.
Newbold (division) brochure was delivery services.
Designers at Aboud-Sodano took their cues from
that. The inspiration for the catalog was taken from
the delivery waybills that courier companies use: It
was printed on actual waybill stock, purchased
from a manufacturer in Japan. Even the envelope
follows the theme.

The Dave and Alex Show

Design firm
The Dave and Alex Show

Designers
Alexander Isley (tickets and stationery), Liesl Kaplan (tickets)

Copywriters
Alexander Isley, Tracie Lissauer (booklet)

Printing
National Ticket Company

Client
Self-promotion

Paper
28 lb. Strathmore Writing Bright White Wove (stationery),
Curtis Corduroy corrugated, Salsa Red (booklet cover);
Mohawk Superfine, Softwhite Eggshell (booklet pages)

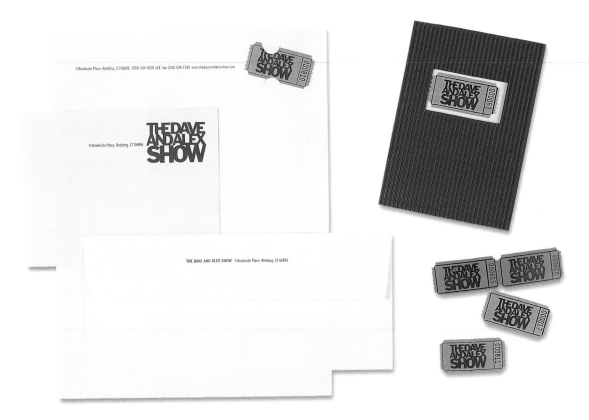

Dave Goldenberg and Alexander Isley met and worked together on a project about 8 years ago and were happy with both the outcome of the project and the way they worked together. They stayed in touch and eventually founded their own agency: The Dave and Alex Show (so named for the dog-and-pony aspect of the business as well as to characterize the energy and collaboration clients could expect).

The idea of tickets as business cards soon followed. They cost just $200 for 10,000 "cards," plus each employee gets to pick his or her own cheesy color, according to Isley. The next logical jump was to use the tickets on the agency's stationery. A recent promotional booklet also uses the tickets on the cover

The Wiser Agency

Design firm
The Wiser Agency

Designer
Heather Cox

Copywriter
Tracey Wiser

Client
Self-promotion

Paper
Velveteen Lilac (cover); 30 lb. Wisteria purple
translucent bond (vellum); Epson Matte heavyweight
paper (cards)

Each year, The Wiser Agency receives rave reviews for the homemade
holiday treats it delivers to clients and associates. In 2001, the Wiser team
decided to give recipients the opportunity to enjoy the baked goods
yearlong, so they enclosed recipes, packaged in a pouch made from velvet-
backed paper and vellum. The velvet stock, which picks up the company's
identity color, was found in a specialty paper store that sells scrapbooking
supplies. It felt wintry and soft, a good match for the packaging of a special
holiday gift.

Takashimaya New York

Design firm
design: mw, new york

Photography
Gentl and Hyers

Client
Takashimaya New York

Paper
Curious Metallics, Lustre and Galvanized;
Curious Translucents, White Iridescent;
Curious Popset, Cryogen White

Not only does the cover and various inside pages of this Takashimaya New York catalog have a shimmery and subtle metallic impregnation, it also contains a lacey, laser-cut flysheet. The sheet is amazingly delicate, almost to the point of being a piece of soft fabric. Takashimaya, an upscale retailer, wants to appeal to people who have a high capacity for seeking out new and different experiences. So the catalog's designer, design: mw, pays close attention to every detail of the publication, including the paper stocks it specifies.

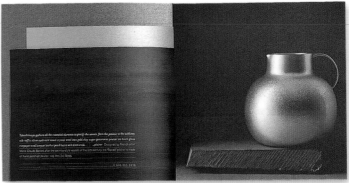

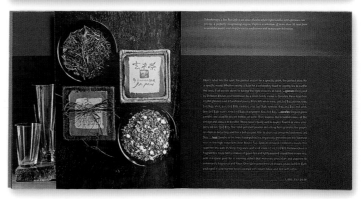

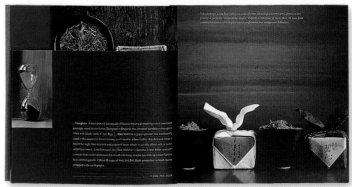

Printed Paper

CHAPTER 6

Designers have always pushed printing to produce more and better results. Cooperative printers got into the act, and applying ink to paper became a fine art. Today, technology is finally catching up. Both the mechanical presses and the paper that runs through them perform more reliably and precisely. The samples in this chapter are evidence of that evolution.

But at the same time, designers are returning to traditional techniques—screen printing, edge-gilding, embossing and debossing—to achieve printing effects that aren't quite as familiar to their audiences anymore. Some, like Independent Project Press, whose work is shown here, become masters at almost forgotten crafts. It's still putting ink on paper, but somehow, it's a lot more exciting.

LPG

Art director
Chris West

Designer, illustrator, copywriter
Rick Gimlin

Client
Self-promotion

This tongue-in-cheek sales kit was created by LPG designers for prospective clients who, fortunately or unfortunately, know the design and marketing fields only too well. Playing on the concept of collectible trading cards tickles the funny bone, and because LPG sent the cards out in small packs over several months until collectors/potential clients had the full set of 24, the firm kept its name in front of clients for an extended period.

The humor in the cards and box is carried nicely by the "super-strength" of microflute corrugated cardboard and nostalgic references like decoder wheels. The wheels and cards each carry a short bio about a specific character that recipients are bound to recognize.

Dorothea van Camp

Design firm
Stoltze Design

Art director, designer
Clifford Stoltze

Client
Dorothea van Camp

Paper
Sappi Strobe, French Construction

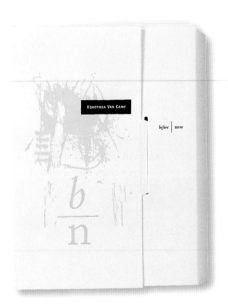

Like any artist, Dorothea van Camp wants every contact with fans of her work to be true to what she's trying to say. So Stoltze Design created a unique stationery system and portfolio packet mailer for the Boston-based painter.

Inside the packet are offset reproductions of van Camp's work, naturally printed on coated paper to preserve their color and resolution. But letterpress printing on uncoated paper was more appropriate for the packaging and stationery.

"Letterpress printing was chosen for its tactile, personal, and slightly imperfect quality," explains Christine Navin of Stoltze Design. The green "scratch" area is a line art, high contrast, graphic interpretation of the artist's work.

Farmhouse

Design firm
Templin Brink Design

Client
Farmhouse

Paper
Industrial grade chipboard (cards); coated MacTac (card stickers)

Zig when everyone else is zagging. That was Templin Brink Design's philosophy for the identity design of Farmhouse, a web site development firm. All of the client's competitors' identities looked high-tech, cold, and sterile. Joel Templin says that their desire was to make Farmhouse feel human. The colors have a solid, Midwestern feel and were inspired by John Deere green. Even on the business cards, small touches make the design personal. The main body of the card is letterpress printed and is even imprinted with a serial code, as if each card were part of a limited edition. Then, because Farmhouse is growing and changing, laser-printed stickers are used to add employee's names and specific contact information.

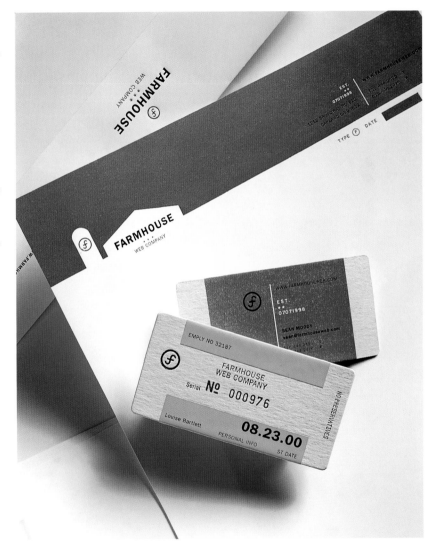

Mires Design

Design firm
Mires Design

Creative director
John Ball

Designer
Miguel Perez

Client
Self-promotion

Paper
Various Crane's cotton papers

Mires Design's previous stationery system used thick, fiber-filled paper stocks to create an earthy, tactile sense. Letterpress printing added to the design's hand-crafted feel. The company's new stationery still uses hefty, meaningful paper, but it has a much crisper, cleaner look. It combines three-color offset printing with debossing, a much sharper approach. Mires designers say the new system reflects the firm's repositioning from a boutique design studio to a strategic, brand-centric design agency. The hope is that it projects a clean, smart, confident statement.

James McGoon

Design firm
Giles Design

Art director
Jill Giles

Designers
Stephen Arevalos

Printer
English Printers

Client
James McGoon

Paper
150 lb. Utopia Premium Blue White cover

Photographer James McGoon's market is largely made up of art directors and designers, so he needed a really intriguing card that would stay in recipients' card files for a long time. Giles Design came up with an innovative solution: edge gilding. The designers kept the card itself simple and elegant, but then used the same old-world process that is used to gild the edges of Bibles to put real shine on the edges of his cards. The cards are stacked, clamped and then a highly reflective silver material is applied. (The design team declined to name its gilder, noting that it took quite a while to find him.) The silver makes a subtle statement about the photographer's use of light and reflection.

Independent Project Press

Designer
Bruce Licher

Printer
Independent Project Press

Clients
The Foundation for Advanced Critical Studies;
Randy Bookasta and Liz Morentin

Paper
Chipboard

Atypicality is the unifying element among these designs. Whereas most wedding invitations are frilly and precious—or at the very least, white—the design here is elegant in a new and different way. Whereas most CD covers are glossy and colorful, these designs rely on the understated shine of metallic and opaque letterpress inks on soft cardstock. Designed and hand-letterpress printed by Bruce Licher of Independent Project Press, all of this work has a tactile, personal feel. "Metallics bring a nice contrast to the chipboard," Licher says. "There's a nice tension between the funkiness of the card stock and the elegance of the ink. Printing metallics on top of another color [as on the "Out of the Overflow" cover] helps bring out their richness even more."

SooHoo Designers

Design firm
SooHoo Designers

Creative and art directors
Patrick SooHoo, Kathy Hirata

Designers
Daniel Ko, Cindy Hahn, Karen Leonard, Leo Terazsas

Client
Self-promotion

Paper
110 lb. Strathmore Ultimate White Script cover

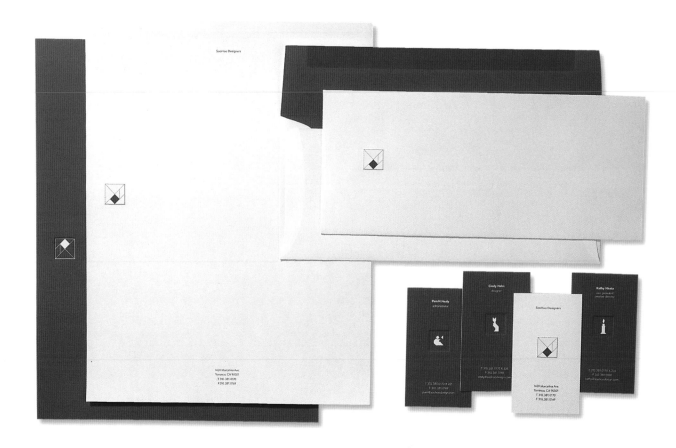

Working closely with their paper supplier and printer helped guarantee success with the dramatic tangram emboss that is the centerpiece of the SooHoo Designers' identity. Creative and art director Kathy Hirata says that understanding the bevel of the emboss die and knowing how much stress the paper would take were crucial to creating the simple sculpture of the tangram mark. Full advantage is taken of the debossed area on the back of the letterhead and business cards. On the back of the stationery, mated directly into the deboss space, is a reverse version of the tangram. On the back of the business cards, every employee has space to do their own tangram art that describes who they are, what they do, or simply what they like.

The Ohio State University Wexner Center for the Arts

Design firm
Salvato, Coe + Gabor

Art director
Steve Gabor

Designer
Andy Kuick

Photographers
Pete Coe (crate), Rick Weber (art reproductions)

Client
The Ohio State University Wexner Center for the Arts

Paper
130 lb. housing and 80 lb. (cards) Mohawk Superfine

In conversations with their client, Ohio State University's Wexner Center for the Arts, designers at Salvato, Coe + Gabor learned about the wooden crates the Center uses to transport art from its collection to its clients, who are image-and pattern-licensing buyers. The heavy crates protect the art in transit: Why not apply the same concept to a direct mailer that would hold cards advertising the same art? The design team traveled to the Center to get a firsthand look at the crates, their construction, and any words and symbols that they carry. From those photos, principal Christopher Coe built a miniature crate and photographed it from several angles. These views were assembled and graphics were applied in Photoshop.

Lippa Pearce Design Ltd.

Design firm
Lippa Pearce Design Ltd.

Art director, designer
Harry Pearce

Printer
Beacon Press

Client
Self-promotion

Paper
250 gsm and 150 gsm Neptune Unique

"I met a man…" was a Lippa Pearce Design Ltd. greeting card sent out at the holidays that was meant to provide a bit of humor and intrigue during the season. A bevy of printing techniques are combined in this piece, including embossing, varnishing, and stitching. All are used to contrast the simple play of words and the typography of the verse. Naturally, the choice of paper was vital to the success: It had to be sturdy but soft, flexible but strong.

Ascension Health

Design firm
Wagner Design

Creative director, designer
Jill Wagner

Art director
Laura Herold

Copywriter, marketing director
Pam Wong

Printer
White Pine

Client
Ascension Health

Paper
Splendor Lux Silver Laser Cover

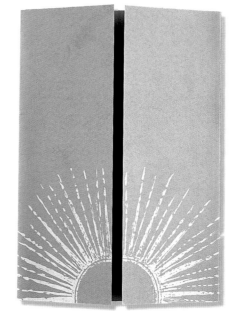

When St. John Health recently merged with Ascension Health, it needed a holiday card to herald the new affiliation. Wagner Design considered the design problem. The firm's designers chose a door format for the card, combining it with light imagery to illustrate the dawn of the new collaboration. They specified a paper with shine of its own: a subtly lined, metallic silver stock. When the "doors" of the card are opened, the shiny silver is revealed, printed with metallic copper and white inks. On the outside of the card—the back of the paper is white—only a touch of silver ink is laid atop a full wash of the metallic copper.

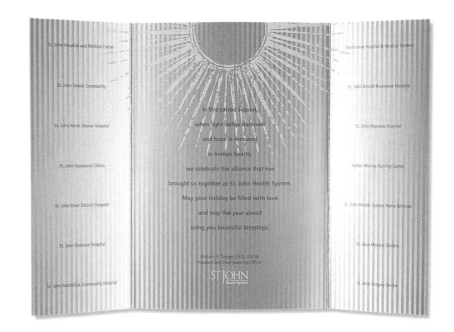

LPG Design

Design firm
LPG Design

Art director
Chris West

Designer
Dustin Commer

Client
Self-promotion

Paper
Assorted colored papers, kraft paper, and liner board

As an attention-grabber for a prospective pizzeria client, LPG Design cooked up a paper pizza, sent complete with a pizza cutter and in a pizza box. "The mystique," says LPG's Dustin Commer, "was to make a food item out of nonfood materials. We wanted to show them [we could] 'think outside of the pizza [box].' "

The toppings were hand-cut out of colored papers, although Commer notes that for multiple copies of such a design, steel rule dies could be produced. The cheese is made from sizzle-wrap packing; the meat, from crushed kraft paper; and the sauce, from red liner board.

Monster Design

Design firm
Monster Design

Client
Self-promotion

Paper
100 lb. Mohawk Superfine

This New Year's card, produced as a self-promotion for Monster Design, has more than meets the eye: It is printed with glow-in-the-dark ink. These inks are treated just like any other spot color on press, reports designer Denise Sakaki. How do recipients know that the card carries the glowing ink? Most of Monster's clients anticipate that when they receive a mailer from the design firm's office, there is something to look for.

ƐM2

Design firm
EM2

Creative director
Maxey Andress

Designers
Harold Riddle, Tanya Mykytka

Writers
Kathy Oldham, Chris Martin

Photography
Burns Studio

Client
Self-promotion

Paper
80 lb. (letterhead, envelope, notepad) and 130 lb. (notecards, business cards, direct mailer) Neenah Classic Crest Solar White text; Neenah Classic Crest label stock (adhesive labels)

The "2-verb" concept that drives EM2's identity system stems from the design firm's branding philosophy: A company's true brand is defined not by rhetoric and market-speak but by the actions the company takes internally and externally. That's why the entire staff participated in generating the "2" actions that populate every piece of the identity system, such as "2think, 2create, 2inspire." In this way, the system became something that every employee could believe in. A paper with a very hard surface was crucial to getting the solid ink coverage that creative director Maxey Andress wanted, so the team specified Classic Crest which provided a smooth surface that didn't pick or mottle.

EM2think.2create.2inspire.

EM2differ.

EM2think.2create.2inspire.

ROBIN SALTER / BRAND MANAGER AND SMARTY-PANTS

121 church street, decatur, georgia 30030
v 404.370.6050 x 119 f 404.370.6040 e. rsalter@em2design.com

EM2think.2create.2inspire.

121 church street, decatur, georgia 30030

2show.

v. 404.370.6050

EM2think.2create.2inspire.

121 church street, decatur, georgia 30030

2read. 2send.

2freckle.2st... invite.2flame.2funk.2lounge...

2prop.2elevate.2accomplish.2grow.2dig.2climb.2rec...

2drive.2live.2love.2imbibe.2laugh.2travel.2learn.2be...

Sadh Desha

Design firm
Scott Wallin Design

Art director, designer
Scott C. Wallin

Photographer
Dee Hein

Client
Sadh Desha

Paper
70 lb. Mohawk Navajo White text

Sadh Desha is described on its letterhead as "a pastoral retreat and yoga sanctuary on Orcas Island"—no doubt the very description of tranquility and enlightenment. When Scott Wallin Design created a stationery system for the retreat, art director Scott Wallin was experimenting with the use of two photos, one of a lily and one of Sadh Desha's building, together with a blue band on the letterhead's front. Then serendipity took over: He noticed that if the two photos on the back of the sheet were positioned in line with the top of the blue area on the front, there was just enough show-through that the photos were just visible. Conceptually and visually, this turned out to be the perfect solution: It is simple and peaceful, and like the experience offered by yoga and meditation, one sees things in a new and different light.

Amanda Turn-Shamback Graphic Design

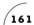

Design firm
Amanda Turn-Shamback Graphic Design

Designer
Amanda Turn-Shamback

Client
Self-promotion

Paper
70 lb. Mohawk Superfine Ultra White, smooth finish text
(letterhead); 100 lb. Mohawk Superfine Ultra white
cover (business card and note card)

Designer Amanda Turn Shamback says the dot pattern in her stationery signifies creative energy. The repetition of
the dots in various shades makes her think of flashing lights, a good metaphor for energy. She selected a suite of
colors that looked fresh and contemporary. Apparently, potential clients agree: Her identity system is usually the first
contact she has with them, and when she makes the dreaded follow-up call, they almost always remember her
stationery. Some even get excited and curious about her choice of colors and paper: Those people usually turn out
to be excellent clients who are open to new ideas and plenty of energy.

KINETIK Communication Graphics

Design firm
KINETIK Communication Graphics

Designers
Jeff Fabian, Sam Shelton, Mila Arrisueno, Beth Clawson,
Richard Fischer, Monica Gornikiewicz, Beverley Hunter,
Ali Kooistra, Katie Kroener, Stephen Oster, Natalie Politis,
Jackie Ratsch, Scott Rier, Kamomi Solidum, Jason Thompson,
Matt Wahl

Printer
Beach Brothers Printing

Client
Self-promotion

Paper
Assorted text sheets, coated and uncoated

A designer at KINETIK Communication Graphics
began binding together laser copy trash for
notepads, and other designers in the studio took
notice: They liked the graphic quality of the
sheets and felt that make-ready sheets from print
jobs might hold even more potential. The idea for
"(re)Collections" was born. They talked to several
printers to find out who was game. One agreed
and, using both KINETIK jobs and non–client
sensitive jobs from other customers, folded the
printed one-side sheet image side in, folded that
in half, and then used perfect binding to pull each
piece together. Each book is completely different.

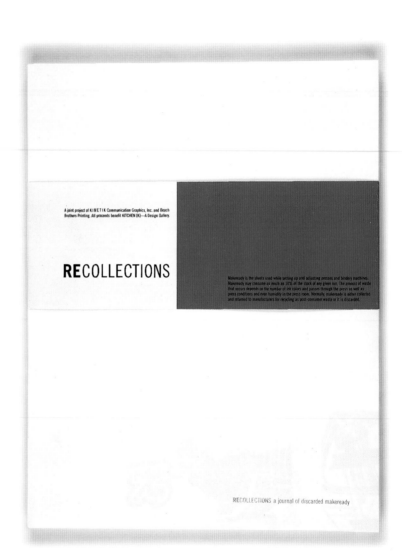

A joint project of KINETIK Communication Graphics, Inc. and Beach
Brothers Printing. All proceeds benefit KITCHEN (K)—A Design Gallery.

RECOLLECTIONS

Makeready is the sheets used while setting up and adjusting presses and bindery machines.
Makeready may consume as much as 10% of the stock of any given run. The amount of waste
that occurs depends on the number of ink colors and passes through the press as well as
press conditions and even humidity in the press room. Normally, makeready is either collected
and returned to manufacturers for recycling as post-consumer waste or it is discarded.

RECOLLECTIONS a journal of discarded makeready

Tower of Babel

Design firm
Tower of Babel

Designer
Eric Stevens

Client
Self-promotion

Paper
Four-ply railroad board

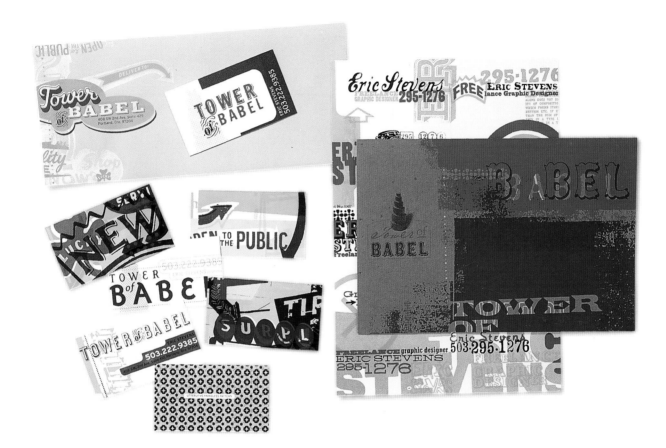

In-house screen printing is what permits designer Eric
Stevens of Tower of Babel to create business cards,
postcards, and other promotions that seem to vary
endlessly: No two pieces appear to have the same
graphics. He gangs postcards and business cards on
the same sheet, then trims them out: Most share image
area, so they can be puzzled back together. What does
he like so much about he what calls "everything but the
kitchen sink" design? A deep love of typography and
signage drive his work, and screenprinting allows him
to make his visions real.

TD2

Design firm
TD2

Design director
R. Rodrigo Cordova

Designer
Rafael Treviño

Client
Self-promotion

Paper
28 lb. and 24 lb. Neenah Classic Crest Brilliant White
(white letterhead and envelope); 24 lb. Neenah Classic
Crest Antique Gray (second sheets)

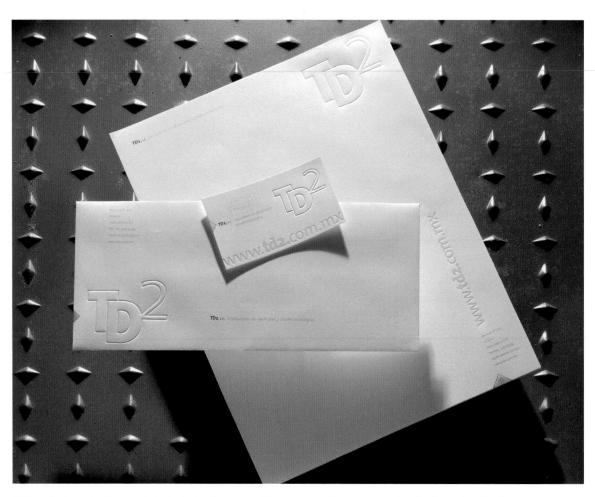

TD2, a Mexican identity and strategic design firm, wanted to create a stationery system that had impact for itself, without falling back on fussy Photoshop effects or type. Elegance was to be at the center of the design. The firm's designers achieved this by combining cotton paper, blind debossing, transparent and silver matte hot stamping, and a minimalist typographic approach. Another twist is the use of white paper for the letterhead's first sheet and gray paper for every page thereafter in the correspondence. Designer Rafael Treviño says the color shift helps his company's correspondence stand out from everything else on a client's desk.

MOO

Design firm
Williams & House

Art director
Pam Williams

Designer
Rich Hollant, CO:LAB

Printer
Pond-Ekberg

Client
MOO

Paper
Via Pure White Smooth, various weights

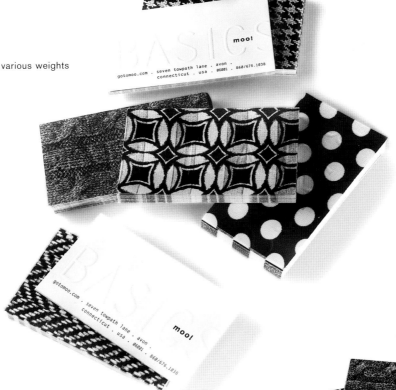

For the identity of Moo, a chic women's clothing store, Williams & House brain-stormed for a way to bring the nature of the outlet to life. The designers solution was to bring the store's lifeblood—fabric—to the fore. On selected envelopes, on sleeves, and on the backs of the business cards, four-color fabric swatches are reproduced in offset inks. Their textures, colors, and even flaws are immediate, allowing the recipient to dive right in to what the store is all about.

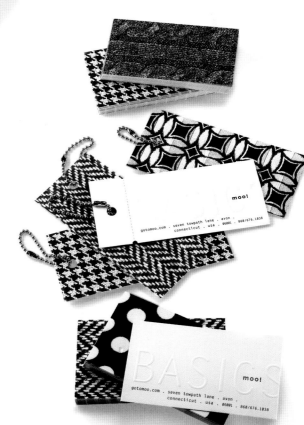

DotZero Design

Design firm
DotZero Design

Designers
Karen Wippich, Jon Wippich

Writer
Gail Tamerius

Client
Self-promotion

Paper
Coated two-sided stock

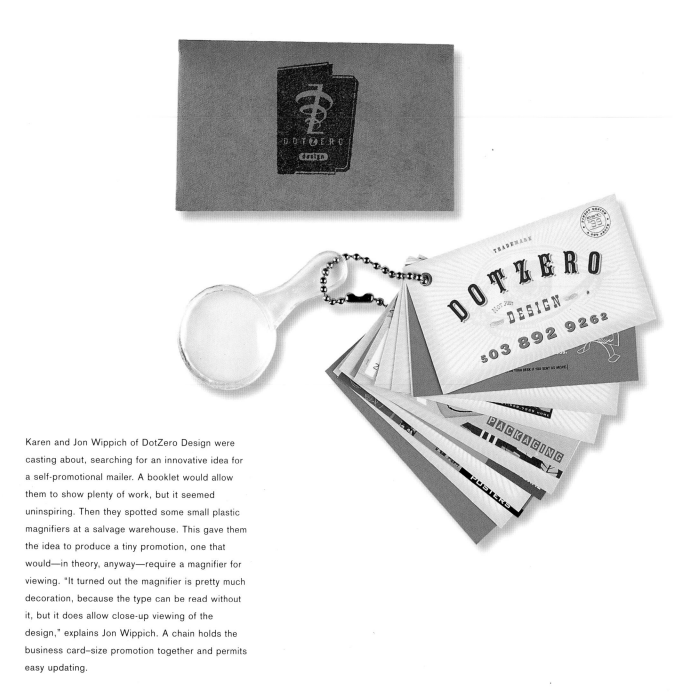

Karen and Jon Wippich of DotZero Design were casting about, searching for an innovative idea for a self-promotional mailer. A booklet would allow them to show plenty of work, but it seemed uninspiring. Then they spotted some small plastic magnifiers at a salvage warehouse. This gave them the idea to produce a tiny promotion, one that would—in theory, anyway—require a magnifier for viewing. "It turned out the magnifier is pretty much decoration, because the type can be read without it, but it does allow close-up viewing of the design," explains Jon Wippich. A chain holds the business card–size promotion together and permits easy updating.

Mixed Media

CHAPTER 7

jürgen witzgall friseur
quellenstrasse 1
6900 bregenz
di - fr 9.00 - 20.00 sa 9.00 - 13.00
tel 05574 529 09

What can paper be combined with? Turn the question
around after reviewing this chapter: What can't it
be combined with? Ribbon, mirrors, plastic, a drink-
ing glass, bags, an electrical plug, even physical
compression—paper works with almost everything
because it's the ultimate mimic. Cut into a wedge
of lemon, it can sit charmingly on the edge of a real
glass. Wrap it with a bit of ribbon, and it becomes
a gift.

The selections in this chapter are predominately
paper based. They rely on other props or additions to
complete their messages, but paper is still at the
core of the design. Each, like this hairdresser's
promo by Sigi Ramoser, cooperate with some other
element to succeed.

Keith Ackert

Design firm
Templin Brink Design

Client
Keith Ackert

Paper
Coated MacTac (sticker)

Keith Ackert is a print broker who deals with all sorts of media—paper, metal, plastic, and more. So Templin Brink Design decided to turn his business card into more of a capabilities piece: The firm's designers used as the card's base a metal card, then they wrapped it with a paper sticker. The various production methods shown—baked-on ink-on-metal printing, adhesive stock, tight print tolerances, and coordination—graphically show the recipient that Ackert has plenty of experience. One added benefit of the metal-paper combination: When the client wants to change information, as he did recently with his phone numbers, all he needs to do is update the stickers.

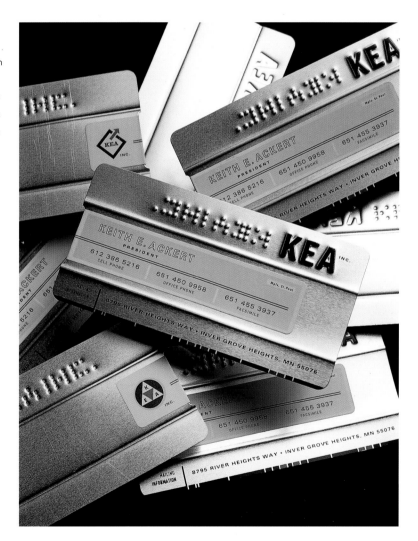

Baseman Design

Design firm
Baseman Design

Designer
Frank Baseman

Writer
Angela Combs

Client
Self-promotion

Paper
100 lb. Mohawk Superfine Eggshell finish cover (card);
2 mil. Mactac Spotlight II Silver Polyester (mirror)

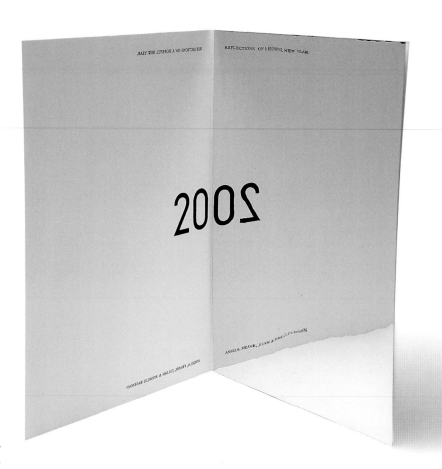

The palindrome of the year 2002 was the inspira-
tion for designer Frank Baseman's recent holiday
greeting card. The mirror idea was actually his
first idea, but he experimented with sharing his
idea through typography and using see-through
materials. But the mirrored stock won out. He
likes the way is card is blank on the outside: It's
mysterious, he says, and when the card is
opened, the surprise is revealed.

Witzgall Hairdressers

Design firm
Sigi Ramoser Designkommunikation

Designer
Sigi Ramoser

Client
Witzgall Hairdressers

Paper
Vellum

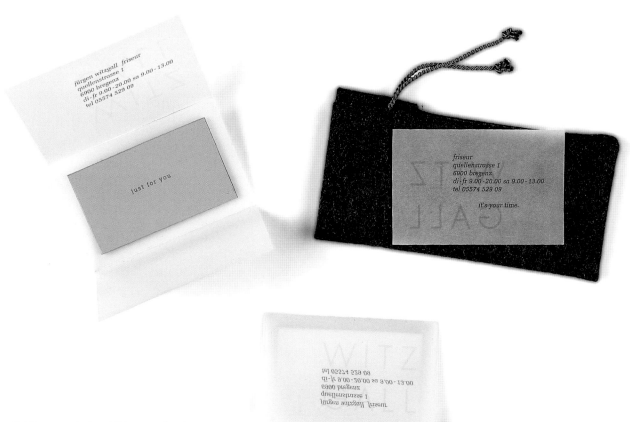

Sigi Ramoser designed this promotional
piece for Witzgall Hairdressers to be a
small gift for the client's customers. Inside a
business card–sized trifold is pasted a small
mirror, imprinted with the words, "Just for
you." There's also space for the hairdresser
to add the date and time of the customer's
next appointment. The entire design is pack-
aged in a soft, gray-black drawstring bag,
making a nice present for the customer.

H-E-B

Design firm
Giles Design

Designers
Jill Giles, Barbara Schooling

Illustrator
Michelle Friesenhahn-Wilby

Printer
Padgett Printing, Dallas

Photography
Tracy Maurer (location shots), Robb Kendrick (head shots), plus stock and corporate archive shots

Client
H-E-B

Paper
French Paper's Packing Carton, laminated to black pressboard; text weight brown kraft; Karma text

H-E-B is one of the largest independently owned retail grocery chains in the United States, with 275 stores and 50,000 employees. It wanted a recruitment brochure that could be taken to colleges and universities to recruit MBAs for executive-level positions. Giles Design was asked to give its client a nonstodgy image and make the grocery business look hip and exciting. Rather than ratchet up the slick factor, Giles designers decided to depend on the honest nature of grocery materials—kraft paper, gray chipboard, and so on—to convey the integrity and down-to-earth quality of the family-owned company.

The bound-in bags were created by printing the kraft paper, and then sending it to an envelope converter who diecut it and serrated its edge, and then folded and glued it. The finished bags then went back to the printer for Wire-O binding into the book. Not only are they an interesting design element, the bags allow different inserts to be put into the book so that it can be customized for specific audiences (pharmacy students, business administrators, and so on).

Smithsonian Air and Space Museum

Design firm

KINETIK Communication Graphics

Designers

Jeff Fabian, Sam Shelton, Beth Clawson,
Beverley Hunter, Ali Koostra, Katie Kroener,
Mimi Masse, Scott Rier, Kamomi Solidum

Printer

Beach Brothers Printing

Client

Smithsonian Air and Space Museum

Paper

Zanders Chromalux Metallic; Potlatch Vintage Dull
Coated; Gilclear

The Smithsonian Air and Space Museum holds an awards program each year. They asked KINETIK Communication Graphics to create an invitation, program, and certificate worthy of this black-tie event, something that felt progressive without being avant garde and that expressed history without being dry. KINETIK designers pulled in an unusual paper for the program portion of the project: a metallic copper paper with enough body to feel like real metal. The copper wrap refers to the materials used in the aerospace industry, and it feels jewel-like and precious. Copper foil stamping is used on the event invitation to tie the two pieces together.

Strathmore Paper

Design firm
Williams & House

T-shirt design
Rigsby Design

Label design
John Johnson Art Direction and Design

Client
Strathmore Paper

Paper
Various Elements stocks

Vacuum packaging is the secret behind these 2 $1/2$ x 2 $1/2$ x 3 $1/2$-inch (6 cm x 6 cm x 9 cm), solid T-shirt cubes, packed complete with a matching paper label promoting the paper line, Elements. Shirt and labels were produced in seven different colors, each with its own elements label: "Sp" for "surprise," "Fk" for "funk," "Un" for "unknown," "St" for "style," "Tr" for "truth," "Dg" for "danger," and "Ele" for "elements." The match of paper color and the cubed shirt make for a cool promotional package.

Pia Wallén

Design firm
Formgivare Henrik Nygren

Designer
Henrik Nygren

Client
Pia Wallén

Paper
110 gr/m Kaskad, Svensk Papper (black sleeve); 700 gr/m
Colorplan, GF Smith, Pristine White

Pia Wallén is a textile designer who works in
strong colors of felt. Because zigzag stitching is
a hallmark of her work, it seemed natural for
designer Henrik Nygren to include, as part of her
identity system, a samples holder that uses
zigzag stitching. Nygren had a sailmaker do the
sewing because using real linen thread was
important to the impact of the design. The effect
is strong and instantly recognizable. Tactileness
is part of the client's identity as well: Product
tags (sample shown here), letterhead, envelopes,
and business cards are all printed letterpress on
hefty paper.

Elvis & Bonaparte Advertising

Design firm

DotZero Design

Designers

Karen Wippich, Jon Wippich

Client

Elvis & Bonaparte Advertising

Paper

Various

A regular advertising agency client of DotZero Design held monthly creative lunches for its staff. DotZero designers Karen and Jon Wippich presented a delicious idea to their client for one such lunch: Why not have an awards show and call it "the Edi's" (as in "the Edibles")? The fun just grew and grew from that point. The call-for-entries was a diner guest check glued into a change tray with a receipt and a few loose coins. Trophies included one for the most fattening dish (a box of lard with a cut-out of Edi, the ficti-tious, bald-headed host of the event), most artistic dish (Edi with a beret and lipstick), and best of show (a cutout of Edi holding a plastic hamburger and hot dog aloft). Entries were numbered with metal "diner specials" holders, and a sugar dispenser served as a ballot box. All materials came direct from a restaurant supply store.

Thistle and Larkspur

Design firm
Giles Design

Art director
Jill Giles

Designers
Barbara Schelling (Thistle), Cindy Greenwood,
Stephen Arevalos

Illustrator, calligrapher
Cindy Greenwood (Thistle)

Printer
Best Wishes (Thistle printed ribbon), Union Bay Label

Client
Thistle and Larkspur restaurants

Paper
Kraft label stock, corrugated kraft coffee sleeves
(Thistle); White matte label stock

The most important part of pulling together inno-
vative and intriguing designs like these two, both
from Giles Designs for two different restaurant
clients, is listening to the client and learning their
business, says copywriter Tyra Simpson. For
both the Thistle and the Larkspur projects, the
designers wanted to stress that all of the restau-
rants' food is made from scratch, using only fresh
ingredients. So a hand-crafted look and materials
were appropriate. Giles Design advises looking
for interesting paper products from industrial
suppliers and steering clear of "designer-y"
supply houses.

Suffolk Association for Jewish Education Services and Jewish Outreach Institute

Design firm
501creative

Client
Suffolk Association for Jewish Education Services
and Jewish Outreach Institute

Printing
Advertisers Printing Company

Gluing of handles and flaps
Project, Inc.

Paper
80 lb. Cougar Opaque text, 80 lb. Royal Fiber Kraft cover

Although this design looks like a shopping bag, it's actually a small booklet was meant to promote Jewish programming that was being conducted in local marketplaces, instead of exclusively at Jewish community centers and schools. It seemed natural to make the design into a bag, although getting the job wasn't simple, recalls Karen Handelman, president of 501creative, the design firm that created the piece. First, her designers had to find a printer who could create a double cover (to hide the base of the handles and any glue), print, and then assemble the piece. Then, when almost all the wrinkles were ironed out, the client considered going back to just printing the handles to save money. 501 won out, and the result was this one-of-a-kind, highly memorable design.

goodesign

Design firm
goodesign

Designers
Kathryn Hammill, Diane Shaw

Client
Self-promotion

Paper
Chipboard (insert); Kea Color, Ice Gold (envelope)

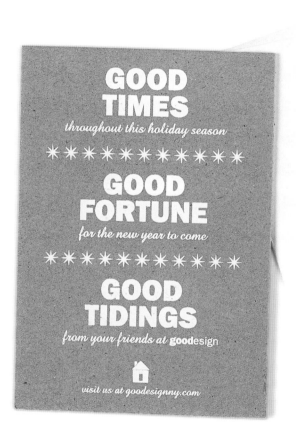

Festive yet unexpected. Low quality yet high quality. Calm yet surprising. All describe goodesign's holiday card, screenprinted on chipboard and tucked into a shimmery, elegant envelope. "The chipboard is unexpected, but most important," says designer Kathryn Hammill, "is that it's understated." The card is also meant to subtly direct recipients to the firm's web site.

Rome & Gold Creative Ltd.

Design firm
Rome & Gold Creative Ltd.

Art director
Brandon Muth

Creative director
Lorenzo Romero

Designer
Brandon Muth, Robert Goldie

Client
Self-promotion

Paper
Epson Photo Quality Inkjet Paper

To promote its new Web site, Rome & Gold
Creative sent out 10 copies of this piece to large
promotional organizations and marketing directors
of specific companies. Because of a limited budget,
an inkjet printer was called into service, together
with a bit of creative thinking. The designers'
objective was to create a piece that would leap off
of the page. Pushing the boundaries of two dimen-
sionality, they spliced a piece of actual cord right
onto the inkjet output. The visual sleight-of-hand
tricks the eye just enough to burn the image into
the mind of the recipient.

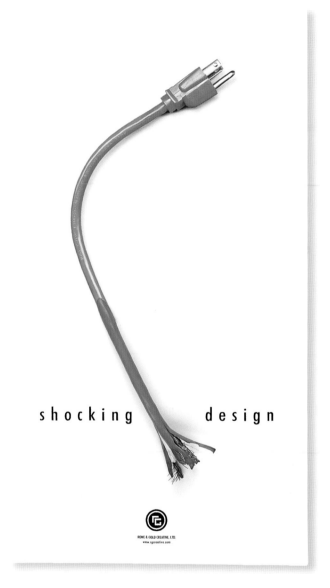

shocking design

ROME & GOLD CREATIVE, LTD.
www.rgcreative.com

Toki

Design firm
Sharp Communications, Inc.

Art directors
Bebe Lee, David Mandy

Designer
Anri Seki

Copywriter
James Brodsky

Printer
Trimensions, Inc.

Client
Toki

Paper
12 pt. Carolina Papers Coated cover

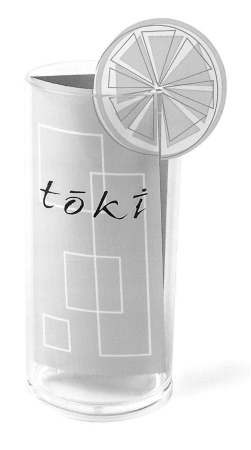

Toki is the first collagen-replacement drink, purported to increase the imbiber's collagen levels by an average of 114 percent. To grab the attention of every major health and beauty editor in New York, Miami, and Los Angeles, its manufacturer asked Sharp Communications to create a launch vehicle that couldn't be ignored. Sharp designers took the concept of the drink literally: They mailed out clear drinking glasses filled to the brim with a product launch-event invitation, complete with a paper lemon wedge on the brim. The client loved the work, praising it as insightful, playful, and informative.

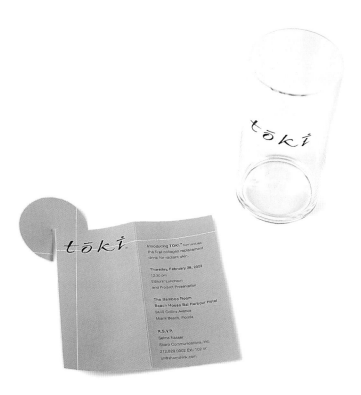

Platinum Design

Design firm
Platinum Design

Creative director
Vickie Peslah

Designer
Kelly Hogg

Copywriter
Frank Oswald

Printer
Enterprise Press

Client
Self-promotion

Paper
Imported plastic

Platinum Design created this "now you see it, now you don't" design as an interactive self-promotion. Inside are four-color pages that display the firm's work. But it's the rivet-bound cover that offers the real surprise: Swing the orange plastic aside, and the promo's message reveals itself. The design team wanted to get across the message that when Platinum creates a project, it isn't solely about how something looks. Strategic thinking goes into each project—meaning that there is "more than meets the eye."

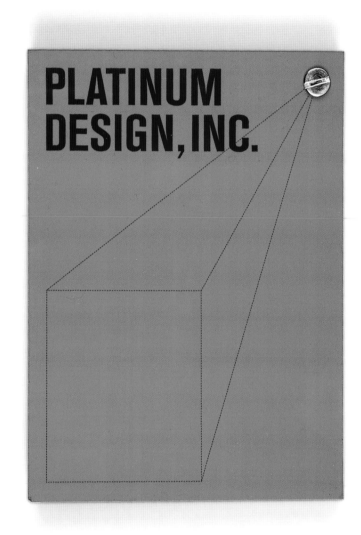

Die Werbedeamen

Design firm
Anne Brodmeier Art Direktion

Art directors
Anne Brodmeier, Kathe Schomburg

Copywriter
Stefanie Hockenholz

Client
Die Werbedeamen

Paper
90 g/qm (wrapper), 150 g/qm (interior samples), and 200 g/qm
(packaging with bite) Galaxi Keramik

What looks like a candy bar is actually a self-promotion for an advertising agency whose name translates to an old-fashioned word for "promotion girl," as in a young lady who might sell treats or refreshments at a public gathering. The title of the promotion translates roughly to "eye feast," which the mock candy bar could be and which the advertising agency hopes the work samples inside are. "Every day," says art director Anne Brodmeier, "potential agency customers have self-promotions landing on their desks. Most aren't very charming, stating simply, 'We are the best.' " So she and her design team went in another direction, hoping that something that made someone smile or at least curious would be more successful.

Tsunami Marketing

Design firm
Wink

Art directors
Scott Thares, Richard Boynton, Anthony Arnold
(Tsunami Marketing)

Designer
Scott Thares

Writer
Scott Jorgenson

Client
Tsunami Marketing

Paper
Various

Tsunami Marketing, an agency based in Koloa, Hawaii, contacted Wink for a marketing brochure to grab the interest of potential clients in the outdoor sports and recreation industries. The agency wanted these parties to see that Tsunami approaches advertising with the same lustful sense of adventure and excitement as they have for life in general. So the brochure not only had to evoke mental images but also had to have a textural feel and pay off in the copy. The mix of materials—including metallic, coated and uncoated stock, an X-ray, and even a bandage—all work together to bring the words to life.

J. Mishra

Design firm
no.parking

Designer
Caterina Romio, Sabine Lercher

Client
J. Mishra

Paper
Uncoated card stock (card); Rowlux Moire,
cellulose propinate (plastic)

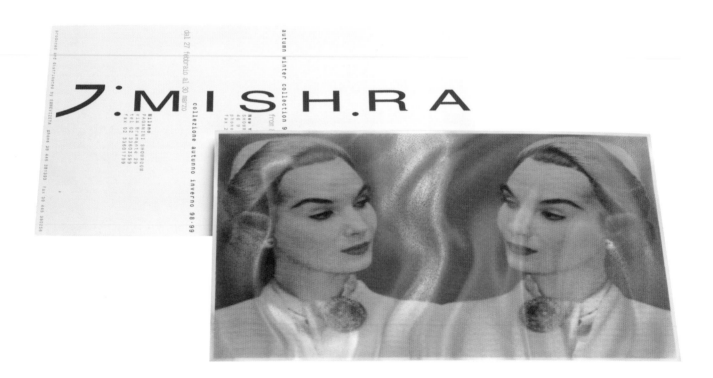

Italian fashion designer J. Mishra wanted a serious, exclusive look for the company's invitation to
the Fall/Winter fashion show. The theme of the collection was cloning, so designers at no.parking
developed a twin image. But to add a touch of mystery and to distance the image from reality a bit,
no.parking designers added a layer of "illusion plastic" on top, adhering it securely to the card
tearing the print run with a thin, bi-adhesive sheet. The result is an image with depth and dimension.

RBMM

Design firm
RBMM

Art director, designer, illustrator
Brian Boyd

Copywriter
Tina Melendez

Paper
80 lb. Starwite Vicksburg Tiara, smooth cover

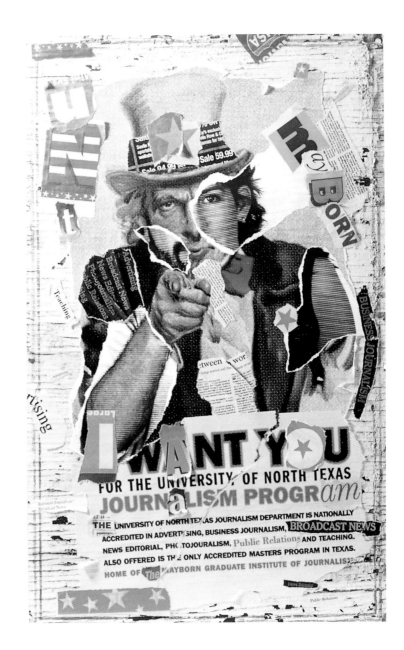

To generate excitement and interest among students enrolling in the Department of Journalism at the University of North Texas, RBMM art director Brian Boyd decided to reference a familiar "we want you" visual. He built Uncle Sam's countenance from bits and pieces of words and images from magazine, newspapers, and digital photos. He felt that using print media as an illustration was an apt way to stress the topic of print media to students.

Directory of Designers

Aboud-Sodano
Studio 7
10-11 Archer St.
Soho, London W1V 7HG
England
Phone: 44 2 7734 2760
www.aboud-sodano.com

Adams Outdoor Advertising
407 E. Ransom St.
Kalamazoo, MI 49007
Phone: 616-342-9831

Anne Brodmeier Art-Direktion
Hans-Henny-Jahnn-Weg 69
22085 Hamburg
Germany
Phone: 40 329 08 356

At Both Ends
63 Trowbridge St.
Arlington, MA 02474
Phone: 617-686-1843
www.atbothends.com

Bailey Lauerman
900 Wells Fargo Center
Lincoln, NB 68508
Phone: 402-475-2800
www.baileylauerman.com

Bartalos, Michael
30 Ramona Ave., No. 2
San Francisco, CA 94103
Phone: 415-863-4569

Baseman Design
221 Mather Rd.
Jenkintown, PA 19046
Phone: 215-885-7157

Burgeff Company
Tecualiapan 36 VW8
04320 Mexico City
Mexico
Phone: 52 5550 4940

Carolyn B. Crowley
400 W. 119th, Apt. 12H
New York, NY 10027
Phone: 212-749-4648

Chen Design Associates
589 Howard St., Fourth Floor
San Francisco, CA 94105
Phone: 415-896-5338
www.chendesign.com

The Dave and Alex Show
9 Brookside Pl.
Redding, CT 06896
Phone: 203-544-9692
www.thedaveandalexshow.com

Design Asylum
46B Club St.
Singapore 069423
Phone: 65 324 8264
www.lunatics@singnet.com.sg

design: mw
149 Wooster St.
New York, NY 10012
Phone: 212-982-7621

Dossier Creative Inc.
305.611 Alexander St.
Vancouver, British Columbia
Canada V6A 1E1
Phone: 604 255 2077
www.dossiercreative.com

DotZero Design
8014 S.W. 6th Ave.
Portland, OR 97219
Phone: 503-892-9262
www.dotzerodesign.com

EM2
121 Church St.
Decatur, GA 30030
Phone: 404-370-6050
www.em2design.com

Fellow Designers
Hälsingegatan 12
11323 Stockholm
Sweden
Phone: 46 8 332200
www.fellowdesigners.com

Finished Art
708 Antone St. NW
Atlanta, GA 30318
Phone: 404-355-7902
www.finishedart.com

501 creative inc.
6321 Clayton Rd.
St. Louis, MO 63117
Phone: 314-863-0501
www.501creative.com

Ford & Earl
350 W. Big Beaver Rd.
Troy, MI 48084
Phone: 248 524 3222
www.fordearl.com

Gardner Design
3204 E. Douglas
Wichita, KS 67208
Phone: 316-691-8808
www.gardnerdesign.com

Gee + Chung Design
38 Bryant St., Suite 100
San Francisco, CA 94105
Phone: 415-543-1192
www.geechungdesign.com

Getty Images
701 N. 34th St., Suite 400
Seattle, WA 98103
Phone: 206-328-4047
www.gettyimages.com

Giles Design, Inc.
429 N. Saint Mary's St.
San Antonio, TX 78205
Phone: 210-224-8378

goodesign
4 W. 37th St., Fifth Floor
New York, NY 10018
Phone: 646-473-1520
www.goodesignny.com

Group Baronet
2200 N. Lamar, No. 201
Dallas, TX 75202
Phone: 214-954-0316
www.groupbaronet.com

GS Design
6665 N. Sidny Pl.
Milwaukee, WI 53209
Phone: 414-228-9666
www.gsdesign.com

Happy Monday
101 Egret La.
Marine, MN 55047
Phone: 651-433-8080
www.happymonday.com

Hess Design Works
88 Quicks La.
Katonah, NY 10536
Phone: 914-232-5870
www.hessdesignworks.com

KINETIK Communication
Graphics
1436 U St. NW, Suite 404
Washington, DC 20009
Phone: 202-797-0605
www.kinetikcom.com

Knauf & Associates
The Brumby Building at
Marietta Station
127 Church St., Suite 310
Marietta, GA 30060
Phone: 770-795-8539

Lippa Pearce Design Ltd.
358a Richmond Rd.
Twickenham TW1 2DU
England
Phone: 44 20 8744 2100
www.lippapearcedesign.com

Meyer & Liechty Inc.
919 W. 500 North
Lindon, UT 84042
Phone: 801-785-1155
www.ml-studio.com

Mires Design
2345 Kettner Blvd.
San Diego, CA 92101
Phone: 619-234-6631
www.miresbrands.com

Monderer Design
2067 Massachusetts Ave.
Cambridge, MA 02140
Phone: 617-661-6125
www.monderer.com

Monster Design
7826 Leary Way NE, No. 200
Redmond, WA 98052
Phone: 425-828-7853
www.monsterinvasion.com

Nygren, Henrik
Asögatan 115
11624 Stockholm
Sweden
Phone: 08 64177 10

no.parking graphic design
Contrá S. Barbara 19
36100 Vicenza
Italy
Phone: 39 0444 327861
www.noparking.it

Parham Santana, Inc.
7 W. 18th St., 7th Floor
New York, NY 10011
Phone: 212-645-7501
www.parhamsantana.com

Peter Felder Grafikdesign
A-6830 Rankwell
Alemannenstrabe 49
Austria
Phone: 43 0 5522 45002
www.feldergrafik.com

Platinum Design
627 Greenwich St., Floor 11
New York, NY 10014
Phone: 212-366-4000
www.platinum-design.com

Pressley Jacobs: A Design
Partnership
1 N. Wacker Dr., No. 950
Chicago, IL 60606
Phone: 312-263-7485
www.pjd.com

RBMM
7007 Twin Hills, Ste. 200
Dallas, TX 75231
Phone: 214-987-6500
Fax: 214-987-3662
www.rbmm.com

RMB Vivid, Inc.
1932 First Ave., Suite 607
Seattle, WA 98101
Phone: 206-956-0688

Rome & Gold Creative, Ltd.
8300 Carmel Ave. NE
Building 6
Albuquerque, NM 87122
Phone: 505-897-0870
www.rgcreative.com

Saldanha Inc.
404 King St. East
Toronto, Ontario
Canada M5A 1L4
Phone: 416-943-0488
www.saldanha.com

Salvato, Coe + Gabor
Associates
2015 W. 5th Ave.
Columbus, OH 43212
Phone: 614-488-3131

Sayles Graphic Design
3701 Beaver Ave.
Des Moines, IA 50310
Phone: 515-279-2922
www.saylesdesign.com

Sharp Communications, Inc.
425 Madison Ave., 9th Floor
New York, NY 10017
Phone: 212-829-0002
www.sharpthink.com

Sigi Ramoser
Designkommunickation
Sägenvier A 6850
Dornbirn
Austria
Phone: 43 5572 27481
www.saegenvier.at

SK Designworks
1831 Chestnut St., 4-Rear
Philadelphia, PA 19103
Phone: 215-568-4432
www.skdesignworks.com

SooHoo Designers
1424 Marcelina Ave.
Torrance, CA 90501
Phone: 310-381-0170
www.soohoodesigners.com

Scott Wallin Design
520 E. Elizabeth St.
Pasadena, CA 91104
Phone: 626-791-9004

Splash Interactive
99 Harbour Sq., Suite 2112
Toronto, Ontario
Canada M5J 2H2
Phone: 416-460-0850
www.splashinteractive.com

Start Design Ltd.
Kingsbourne House
229-231 High Holborn
London WC1V 7DA
England
Phone: 44 20 7269 0101
www.startdesign.com

Stone & Ward
225 E. Markham
Little Rock, AR 72201
Phone: 501-375-3003
Fax: 501-375-8314

Tower of Babel
408 SW 2nd Ave., Suite 429
Portland, OR 97204
Phone: 503-222-9385

Turn-Shamback, Amanda
214 Upham St., No. 181A
Mobile, AL 36607
Phone: 251-476-4253

TD2
Ibsen 43, 8° piso
Polanco 11560 Mexico D.F.
Phone and fax: 01152 81 6999
www.td2.com.mx

Turquoise
1479 NW 80th St.
Seattle, WA 98117
Phone: 206-783-5993

Velocity, Inc.
306 Dartmouth St.
Boston, MA 02116
Phone: 617-247-1111
www.velocityadvertising.com

Vinje Design, Inc.
1045 Contra Costa Dr.
El Cerrito, CA 94530
Phone: 510-528-3578
www.vinjedesign.com

Vrontikis Design Office
2707 Westwood Blvd.
Los Angeles, CA 90064
Phone: 310-446-5446
www.35k.com

Wagner Design
455 E. Eisenhower
Ann Arbor, MI 48108
Phone: 734-662-9500

Werkhaus Creative
Communications
1124 Eastlake Ave. East
Seattle, WA 98109
Phone: 206-505-8305

The Wiser Agency
Bayport One, Suite 420
8025 Black Horse Pike
West Atlantic City, NJ 08232
Phone: 609-569-1717
www.thewiseragency.com

Zulver & Company
34 Southern Row
London W10 5AN
England
Phone: 44 20 8962 6699
www.zulver.com

About the Author

Catharine Fishel writes for many design-related periodicals and Web sites, including *PRINT*, *Step Inside Design*, *ID*, LogoLounge.com, *Applied Arts*, and *U&lc Online*. She is the author of *Paper Graphics*, *Minimal Graphics*, *The Perfect Package*, *Redesigning Identity*, *Designing for Children*, *LogoLounge* (all Rockport Publishers), and *The Inside Business of Graphic Design* (Allworth Press).